PHOTOGRAPHING
WILDLIFE

PHOTOGRAPHING WILDLIFE
IN THE CANADIAN ROCKIES

Dennis & Esther
S C H M I D T

LONE
PINE

First printed in 1991 5 4 3 2 1

Printed in Singapore

The Publisher:
Lone Pine Publishing
206, 10426-81 Avenue
Edmonton, Alberta
Canada
T6E 1X5

Canadian Cataloguing in Publication Data

Schmidt, Dennis, 1921-
Photographing wildlife in the Canadian Rockies

ISBN 0-919433-46-4

1. Photography of animals — Rocky Mountains, Canadian (B.C. and Alta.)* 2. Nature photography. I. Schmidt, Esther, 1922- II. Title. TR727.S34 1990 778.9'32 C90-091511-0

Book & Cover Design: Yuet Chan
Editorial: Mary Walters Riskin
Mapping: Rick Checkland
Printing: Kyodo Printing Co (S'pore) Pte Ltd

The publisher gratefully acknowledges the assistance of the Federal Department of Communications, Alberta Culture and Multiculturalism, the Canada Council, the Recreation, Parks and Wildlife Foundation, and the Alberta Foundation for the Literary Arts in the publication of this book.

*We dedicate this book to all grandchildren.
May they grow to respect and appreciate
the wonders of every living thing.*

CONTENTS

Introduction 9

Photographing Wildlife 11

Cameras and Equipment 35

Aids to Wildlife Photography 39

Mammals 48

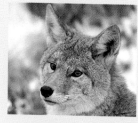

Black Bear 50
Grizzly Bear 52
Marten 54
Fisher 56
Wolverine 58
Badger 60
Coyote 62
Gray (Timber) Wolf 64
Red Fox 66
Mountain Lion 68
Lynx 70
Bobcat 72
Hoary Marmot 74
Columbian Ground Squirrel 76
Golden-mantled Squirrel 78
Yellow-Pine Chipmunk 80
Red Squirrel 82
Beaver 84
Deer Mouse 88
Muskrat 90

Porcupine 92
Pika 94
Snowshoe (Varying) Hare 96
Wapiti (Elk) 98
Mule Deer 102
White-tailed Deer 104
Moose 106
Woodland Caribou 108
Bison 110
Mountain Goat 112
Bighorn Sheep 114

Birds 116

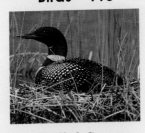

Common Loon 118
Hooded Merganser 120
Osprey 122
Bald Eagle 124
Golden Eagle 126
White-tailed Ptarmigan 128
Ruffed Grouse 130
Great Gray Owl 132
Belted Kingfisher 134
Yellow-bellied Sapsucker 136
Northern Flicker 138
Gray Jay 140
Steller's Jay 142
Clark's Nutcracker 144
Magpie 146

Common Raven 148
White-breasted Nuthatch 150
Mountain Bluebird 152
Cedar Waxwing 154

Frogs, Flowers and Insects 156

Frogs 158
Blue Clematis 161
Globeflower 162
Ox-Eye Daisy 164
Bergamot 166
Wild Crocus 167
Indian Pipe 168
Mountain Lady's Slipper 170
Columbian Lily 172
Green Hairstreak 173
Clouded Yellow 172
Grasshopper 174
Katydid 176
Damselfly 178
Polyphemus Moth 179
Cuckoo Wasp 180
Bumble Bee 182
Orb Spider 184
Wolf Spider 186
Gossamer Threads 187

References 189

INTRODUCTION

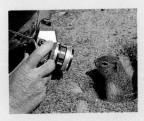 Millions of visitors arrive in the mountain parks each year to photograph and marvel at the scenery and the abundant wildlife, to experience the hotsprings, to participate in the winter sports, or simply to shop at some of the exclusive stores located in Banff, Jasper, Lake Louise and Waterton townsites. Visitors return again and again to enjoy the changing of the seasons and to capture the mountains and the wildlife on film.

We are among those who have returned, and our cameras have captured multitudes of images, some of which we would like to share with you here. This book is a guide to further your enjoyment of your surroundings, to assist you in locating wildlife for viewing or photographing, and to help you identify, as well as understand, the animals of the mountain parks.

We thank Grant Kennedy, Mary Walters Riskin and Bev Hills, all of Lone Pine Publishing, for their support of this project, and Dr. Geoff Holroyd for verifying the authenticity of the wildlife descriptions.

Dennis and Esther Schmidt

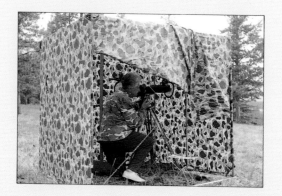

PHOTOGRAPHING WILDLIFE

THE EQUIPMENT

The following is an overview of the equipment we use in the field. Our discussion is not an attempt to discredit any type of film or photographic equipment, but is simply an explanation of what has worked well for us throughout our photographic experiences. If you use different films and cameras than we do and have good results, then by all means stick with them.

Beginning photographers may wish to start with the second chapter, where cameras and their technical operations are explained. The Aids to Photography chapter may prove useful to both new and more experienced photographers.

Photography can be a lot of fun or it can be a headache. We prefer the fun part, and the togetherness it affords us when we are working as a team.

Cameras

The 35 mm single-lens reflex interchangeable lens camera is almost the universal choice of wildlife photographers today, and has been for two decades, because of its convenience: especially its small size, large film capacity, and excellent lens quality and selection. Other camera types can be and are used, such as the 6 x 6 cm makes, or even larger film sizes, but the 35 mm single-lens reflex is the overwhelming choice.

Dennis usually carries two 35 mm single-lens reflex Minolta cameras, each mounted with a lens of a different focal length, in order to be prepared for whatever subject may turn up. He may have a 200 - 500 mm zoom lens on one camera (to bring distant objects closer) and a 50 mm lens on the other. This combination covers every photographic possibility, from a mountain goat on a high, distant ledge, to a scenic.

Esther uses a 35 mm Ricoh as well as a Minolta. Both cameras work well for her needs and are real workhorses, having given no problems over the years. If in doubt when purchasing a camera, consult the following chapter and then ask any reliable camera repairman or serious wildlife photographer for his opinions.

Lenses

Our equipment ranges from wide angle lenses (28 mm & 35 mm) for scenics, through 800 mm for distant wildlife shots. Our favourite lens is the Tamron 200 - 500 mm zoom, as this enables

us to take portraits or full body shots without changing our position or lens. Most of the photographs within these pages were taken with this lens (mounted on a tripod, with a cable release attached to the shutter release button in order to avoid camera shake). The Tamron 80 - 200 mm zoom is another favourite as the results are very sharp and clear, and it has the added benefit of being a "fast" lens with a maximum aperture of f2.8, a decided advantage when working in low light situations.

Film

Most publishers demand slides, and photography is our business as well as our pleasure. Slides can be viewed by a large group more easily than can one or two viewing prints. We often share our wildlife experiences with school children and other non-profit groups, a practice which you too may find very satisfying.

For these reasons, we use Kodachrome 64 positive (slide) film exclusively. Admittedly Kodachrome 25 is a more perfect film with finer image resolution, while Kodachrome 200 is faster (more light sensitive), but our choice of ISO (ASA) 64 gives us the required speed for most situations and the grain in colour enlargements (prints) is excellent.

Blinds

We occasionally find blinds an asset, more with birds than with mammals as the latter's super keen sense of smell is hard to deceive. Once we set up our blind twelve metres from a very dead cow, in hopes of photographing bears. Several did investigate but, upon catching our scent, quickly retreated: not a very flattering experience, especially as the wind was in our favour and the perfume from the carcass was overwhelming. (For more information on blinds, refer to the Aids to Photography chapter.)

Other equipment

The following items have proved useful on our photography expeditions. Many of them are discussed more fully in the Aids to Photography chapter.

It is worthwhile to include a multi-coloured jacket or shirt on your photography expeditions, to break the harsh human image in the eyes of your potential subjects.

Instant glue and strong string have many uses in photography, as have a mirror or a reflector made from a piece of cardboard covered with wrinkled aluminum foil.

A bean bag can serve as an emergency tripod.

A blow brush for blowing out the inside of your camera when changing film will eliminate most scratches and dust marks on your pictures.

Take along some lens-cleaning tissues, extra batteries for your camera, lots of film of course, extra lenses if you have them such as a 200 mm or a 400 mm for a closer look at wildlife and a 28 mm wide angle lens equipped with a polarizer for scenics. A set of close-up lens attachments is extremely useful for flowers, and a bellows is even better.

If you do not have a refrigerator in your vehicle, a cool place in which to store your film should be considered.

You will need a gadget bag, or something with lots of pockets, in which to carry your equipment. When purchasing a bag, try to get one that does not advertise the fact that it contains camera equipment, as this may lead to theft.

THE COMPONENTS

Composition

Good composition can often turn an ordinary photograph into one of artistic beauty. By correct placement of the subject and leading lines to that subject, one can add interest, achieve a deeper sense of belonging, and produce a more pleasing image. A well exposed, sharp picture is not enough: it should have a story to tell.

Diagonal lines create drama, illustrate depth and take the eye to the subject. Erratic vertical lines create excitement, while horizontal wavy lines induce calm. By placing a mountain goat at the top of a vertical frame, with the cliffs falling sharply under it, you reveal the type of country the animal prefers while at the same time creating a feeling of solitude and awe. A horizontal photo of a female mountain goat with a young kid at rest gives the feeling of tranquility and tenderness. Mountain peaks should be close to the top of the frame to express grandeur while lakes and rivers reveal calm as they hug the grasses along the bottom of the frame.

A frame of branches or leaves will often enhance the picture, as will a winding path leading to your subject. The path should never leave the frame exactly at a corner, as this tends to take the viewer's eye out of the photograph.

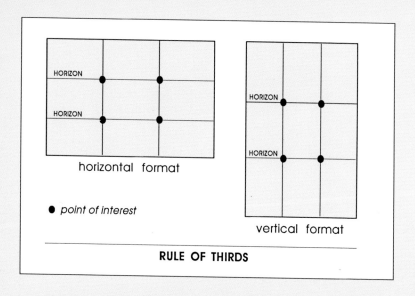

horizontal format

● point of interest

vertical format

RULE OF THIRDS

The basic "Rule of Thirds" nicely covers composition and is simple to remember. Horizons should almost always be placed across either the top or bottom third of your frame (ensuring that they are not tilted). The only time this Rule of Thirds is success-fully broken is when you want the horizontal image to be exactly halved for one reason or other.

Your point of interest should be placed at or near one of the four points where the lines intersect, and not in the centre of the frame. Again this rule can be broken if the subject is clearly halved, as the inside of a church may be, a totem pole or a front view (close-up) of a face.

Examples of these techniques will be found in the section on Photographing Scenics, at the end of this section.

Lighting

Low sunlight in the morning is, at times, hauntingly beautiful. It will seep under the trees to open up the forest, and give light to the eyes of your subjects. You can use this morning light for backlighted or sidelighted shots to give fur and feathers a lovely rim-lit halo effect. To achieve this, automatic camera holders need only aim and shoot. With a manual exposure camera, take a reading for front light, then open up one half stop (f 8 to f 6.9) for sidelighting, or one full stop for backlighting.

The hours between 11 a.m. and about 1:30 p.m. are the worst time for photography: the sun, straight overhead, gives everything an uninteresting look, and photos have no character. This is an excellent time for reading a good book or taking a snooze.

The best light for wildlife is a slightly overcast sky, as the reflected light from white clouds tends to fill in the harsh shadows while still allowing you to operate on a relatively fast shutter speed. If a storm approaches and there are still patches of sunlight, expose for the sunlight — not the beautiful dark clouds.

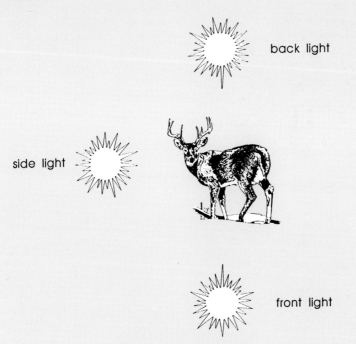

back light

side light

front light

DIRECTION OF LIGHTING

The Subject

Decide what you want to include in your photograph. Do you want a portrait, a full body shot, or a photo which includes the animal's environment? With a fixed-focal length, automatic camera, you do not have much choice: close-ups of wild animals are too dangerous to contemplate. With a telephoto lens to bring the image closer to you, you have a much better chance of getting a more intimate shot. Wildlife inclines to photograph better if taken at an angle rather than in full profile.

Always try for a catch light in the eye, as this makes your subject more alive. This is especially true in a close-up shot. Low evening light is best for giving sparkle to the eyes of a bear.

Small animals make much more appealing subjects when photographed at eye level. Don't hesitate to get down on your knees or your tummy and wait for the right expression.

Patience is one of the most important ingredients in wildlife photography. We have waited a week or more in an animal's territory, in order to establish trust and eliminate the look of fear from the animals in our pictures. It is a wonderful feeling to have a wild creature allow you to photograph with a normal lens, to let you remove some nearby grass without cowering, or — under the right conditions — to lick your face in friendship.

CAUTIONS FOR WILDLIFE WATCHERS

Some of our wildlife has become accustomed to vehicles along the highways, and these animals will tolerate parked cars to a large extent. But once the door is opened and people appear, most wild animals feel threatened and will either move out of good camera range or disappear altogether. By remaining in your vehicle and "shooting" through the open window, your chances of excellent results are increased.

Photographers, tourists and naturalists are more mobile along hiking trails, campgrounds and picnic sites and animals there have become conditioned to human presence. One must use discretion at all times with wildlife as they can be unpredictable. Fast movements are regarded as a threat. Therefore, move slowly, quietly and deliberately to a closer vantage point.

Be aware of these major cautions:

Never approach predators at a kill, bears with cubs, moose, deer or elk with young or during rut.

Never cut off an animal's escape route. If threatened, back off slowly but never run, as then you may become "prey" in the eyes of the animal.

Each animal has its own particular way of showing it is not comfortable and feels threatened, and only experience will allow you to recognize these signs. Park animals are protected, but not tame. They are wild creatures, requiring lots of elbow room: allow them that or they could become defensive. Each animal has its own territory and will protect it just as you do yours.

Never feed the wildlife in the national parks, as this practice could lead to both human and wildlife injury or death.

When hiking into the wilderness, to take photographs or for any other reason, never use perfumes, scented deodorants, hair sprays, tobacco or other scented product. If you carry food, make sure it is packaged to give off no scent. Women should avoid hiking in predator country during menstruation.

A few simple precautions and a large dose of common sense will reward you greatly in your search for an excellent opportunity to photograph. Respect for the national parks and their wildlife will assure you of experiences long to be remembered.

PHOTOGRAPHING WILDLIFE

The principal rule in locating wildlife is to go where the animals feed. Wild animals do not live by the calendar: nature provides the rules for them. If the dandelions bloom late in the spring, the plant-eaters will be late in arriving. If it is a good year for berries in the fall, bears feeding on grass or roots will not be as abundant along the roadsides. In short, all creatures go where nature has provided the food and shelter they require to exist and breed. In these pages we can give only the locations and the seasons that have favoured our sightings. These are guides, not guarantees.

There are no hard and fast rules in photographing nature. What is required is a feeling for your subject, an understanding of the environment and a knowledge of your equipment.

Parking lots adjacent to lookout points and picnic sites such as those at Peyto Lake and Bow Lake in Banff National Park, Mount Edith Cavell in Jasper, Emerald Lake in Yoho, Wardle Creek in Kootenay Park and Red Rock Canyon and Cameron Lake in Waterton, are frequent hosts to visiting birds and home to small mammals. These areas afford wonderful opportunities for even the simplest of cameras. With patience and slow movements it is surprising how closely one can approach these people-watchers.

Often the birds will come back time and again to the same perch, making it possible for you to focus ahead on that particular spot. It is not unusual for them to land on or in your vehicle; some of the braver ones will even use your shoulder or hand as a landing field.

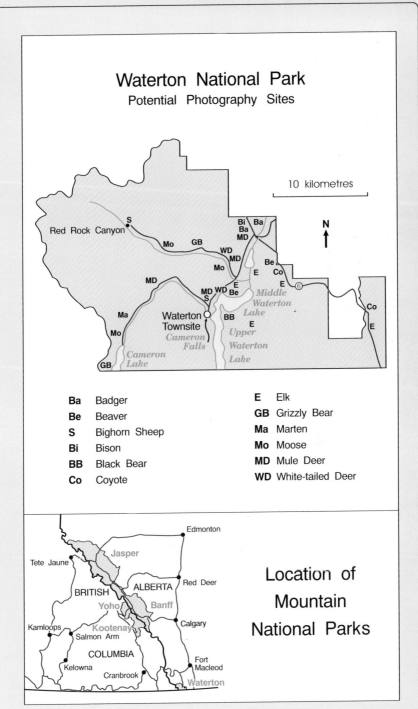

Waterton National Park
Potential Photography Sites

10 kilometres

N

Red Rock Canyon

Bi Ba
Ba
MD

Mo GB

WD
MD

Mo

Be
Co

E

E

MD

MD WD E
S Be

Middle
Waterton
Lake

Ma

Waterton
Townsite

BB

Co

E

Mo

E

Upper
Waterton
Lake

E

Cameron
Falls

Cameron
Lake

GB

Ba	Badger	**E**	Elk
Be	Beaver	**GB**	Grizzly Bear
S	Bighorn Sheep	**Ma**	Marten
Bi	Bison	**Mo**	Moose
BB	Black Bear	**MD**	Mule Deer
Co	Coyote	**WD**	White-tailed Deer

Edmonton

Jasper

Tete Jaune

BRITISH

ALBERTA

Red Deer

Yoho

Banff

Kamloops

Kootenay

Calgary

Salmon Arm

COLUMBIA

Kelowna

Cranbrook

Fort
Macleod

Waterton

Location of Mountain National Parks

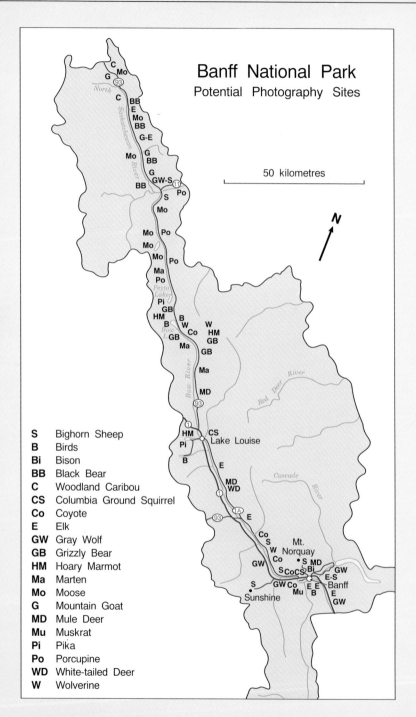

Banff National Park
Potential Photography Sites

50 kilometres

N

S	Bighorn Sheep
B	Birds
Bi	Bison
BB	Black Bear
C	Woodland Caribou
CS	Columbia Ground Squirrel
Co	Coyote
E	Elk
GW	Gray Wolf
GB	Grizzly Bear
HM	Hoary Marmot
Ma	Marten
Mo	Moose
G	Mountain Goat
MD	Mule Deer
Mu	Muskrat
Pi	Pika
Po	Porcupine
WD	White-tailed Deer
W	Wolverine

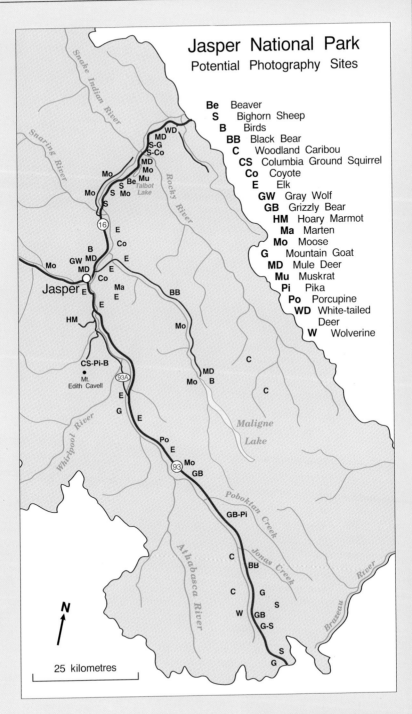

Jasper National Park
Potential Photography Sites

Be Beaver
S Bighorn Sheep
B Birds
BB Black Bear
C Woodland Caribou
CS Columbia Ground Squirrel
Co Coyote
E Elk
GW Gray Wolf
GB Grizzly Bear
HM Hoary Marmot
Ma Marten
Mo Moose
G Mountain Goat
MD Mule Deer
Mu Muskrat
Pi Pika
Po Porcupine
WD White-tailed Deer
W Wolverine

N

25 kilometres

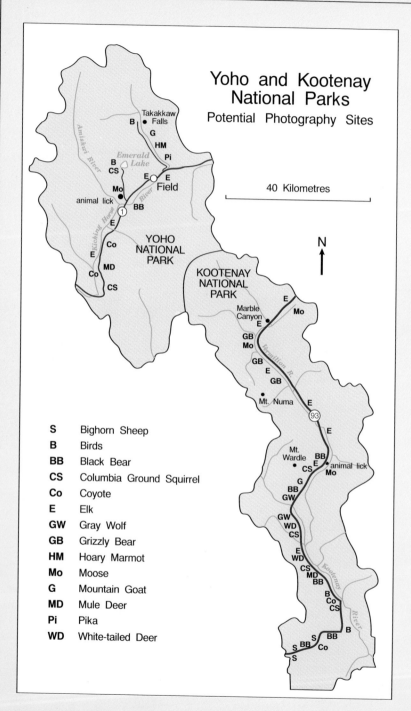

Yoho and Kootenay National Parks

Potential Photography Sites

Takakkaw Falls
B

G

HM

Emerald Lake

B
CS

Pi

E
E
Field

Mo

animal lick

BB

1

E

E

Co

E

MD

Co

CS

40 Kilometres

N

YOHO NATIONAL PARK

KOOTENAY NATIONAL PARK

E

Marble Canyon
E

Mo

GB
Mo

GB
E

GB

Mt. Numa

E

93

E

Mt. Wardle

BB
E

animal lick

CS

Mo

G

BB

GW

GW

WD

CS

E

WD

CS

MD

BB

B
Co

CS

B

S
BB

BB

S

Co

S

S	Bighorn Sheep
B	Birds
BB	Black Bear
CS	Columbia Ground Squirrel
Co	Coyote
E	Elk
GW	Gray Wolf
GB	Grizzly Bear
HM	Hoary Marmot
Mo	Moose
G	Mountain Goat
MD	Mule Deer
Pi	Pika
WD	White-tailed Deer

Small Mammals

Ground squirrels are very easy to photograph in areas which humans frequent: we've found the Wardle Creek campground in Kootenay National Park particularly successful. These little charmers will almost pose for you. Lower yourself to their level, lying down if necessary, to get a more intimate shot. Again, try to catch a little light in the eye of your subject, thereby bringing your photograph to life.

Not only is it unlawful to feed wildlife in the mountain parks, but such things as bread, potato chips, salted nuts and so on are injurious to the health of birds and animals. By watching carefully, you can learn the natural preferences of each species. Gather some of that particular food without damaging the food source, place the food where you would like your subject to appear in your photograph, and wait. You will be rewarded with a more interesting photograph and your subjects will get their dinner without working as hard as usual.

A remote control device works well with small animals such as ground squirrels, pikas, mice and marmots. Set your camera on a tripod or bean bag close to the burrow or frequently used rock or trail. Attach a remote control cord to the shutter release button on your camera, check to see what area your lens sees in the viewfinder, settle some distance away and relax. Trip the shutter when the subject is within your viewfinder's field of vision. It could be to your advantage to use a blind if you locate one of these little creatures away from a well travelled area.

Large Mammals

Some areas of the mountain parks offer a greater chance for successful photography of certain wildlife species than do others. The following locations are fairly accessible and we have identified them as the easiest places to take pictures of certain species, using even a simple camera, when including habitat is not a high priority.

The following five mammals can be successfully photographed in many other areas of the Rocky Mountain parks, as can many other species. Photographing wildlife always includes the element of chance: it is always a case of being in the right place at the right time. One tourist with whom we spoke one day had just photographed a wolverine right beside the road at Bow Lake located in Banff National Park.

Bighorn Sheep In Waterton Lakes National Park bighorn sheep are often seen along the roadside close to town or out at the parking lot near Red Rock Canyon, where they are relatively easy to photograph.

In Kootenay National Park you may locate bighorn beside Sinclair Creek, close to the south park entrance, or along the red cliffs in that area. These are excellent spots for those using fully automatic cameras.

In Banff National Park, check the cliffs and roadsides at the south end, where Highway 1A begins. Sulpher Mountain (via the gondola), the road to the Sunshine Ski area, Mount Norquay and the Lake Minnewanka picnic area are also likely sites.

Jasper National Park has a number of excellent bighorn photography opportunities for enthusiasts with simple cameras. A hike up Wilcox Pass near the Columbia Icefields could reward you with beautiful habitat shots of bighorn. Look for them along the roadside and cliffs at Tangle Falls. Disaster Point, located northeast of Jasper townsite along the main highway, is home to a large herd of bighorn sheep. In the spring, the ewes and lambs are frequently seen by the roadside.

Mule Deer Waterton Townsite Campground is the most likely place in all of the Rocky Mountains for photographing these deer. The mule deer here are accustomed to people, and enjoy the fresh green grasses of the campsites and gardens of Waterton.

Bison There are two bison paddocks in the parks which provide good opportunities for photography. One is close to Banff townsite and the other just north of the main gate at Waterton. Both sites are capable of producing fine habitat shots. Only vehicular traffic is permitted in these areas, and the Waterton enclosure is only open during the summer months.

Mountain Goats When the mountain goats come down from the high country, Mount Wardle in Kootenay Park affords tremendous photographic opportunities. Look for them also along the roadside area and against the clay cliffs at Athabasca Lick, approximately 30 kilometres south of Jasper townsite.

In both locations, the white goats will be seen against light-coloured backgrounds, so you will need to watch your exposure. Use your light meter with a grey card (or use an incident light meter) to measure the light falling on the subject, rather than the light reflected from the subject. Fully automatic cameras may not be capable of achieving correct exposure unless some dark areas are included.

Elk Again the campgrounds afford the best opportunities for successful photographs. The area in and around Whistler Campground near Jasper townsite is an excellent location, both in the spring and in the fall during rut.

Birds

The easiest time to film birds is during nesting season, which usually occurs during June or early in July. At this time, the adults are very busy feeding their ravenous offspring, and will return time after time to the same branch or tree cavity. If the perch or tree is not particularly photogenic, you can make it so. Find an interesting dead branch, glue on some lichen, moss or other vegetation, making the effect as natural as possible. Then, using some string, securely fasten this branch close to the nest or hole. This temporary landing spot for the adult bird is easily removed after you are finished shooting. If the nest itself interests you but is obscured by leaves or branches, tie these back with string, being careful not to break them as they must be replaced for the safety of the young birds against hot sunshine and predators.

Few birds object to flash, and a 200 mm lens with flash and a tripod is the ideal way of handling a nesting situation. If you do not own a flash unit, the reflected light from a mirror or crumpled aluminum foil, directed into the nest, will fill in the shadows and capture the light in the eye of the bird.

Simple cameras can be mounted on a homemade remote control device to which a long string — which activates the shutter — has been attached. (See illustration on page 47.) The camera can then be firmly positioned close to the nest and you can shoot from a distance.

You may want to switch to a fast film, such as ISO 400, for low light conditions. Your pictures will not be as sharp as they would be with a slower film, but will be fine for home viewing.

Some birds are easily spooked and will not tolerate humans very well. In such cases a blind should be used to ensure that feedings are not interrupted.

On the other hand, some birds such as the cedar waxwing will accept food for their young that has been placed close to the nest by humans. Watch carefully to see what type of berry the adult is bringing to the nest. Then, gather some yourself.

The same tactic holds true while the nest is being built. Locate an old nest of the previous year, place it close to the work area, and often the birds will use some of the old material.

These two tricks of the trade allow you to get more photographs in a shorter period of time, and may even save the birds some work.

Insects

The warm months of summer are a fantastic time for insects. A wonderful variety of butterflies may be found feeding on nectar in the meadows or sucking up chemicals from the mud of the wet areas surrounding marshes and lakes. While feeding on the chemicals, the butterfly is not easily distracted; therefore it is possible to get in close with your camera. Close-up attachments are an asset in this situation.

Nectar-feeding insects are often attracted by stale beer, honey, syrup or sugar water spread close to or sprayed on their food source. This provides an excellent opportunity for daytime pictures. At night, hang your camp lantern close to a white cloth and see how many visitors you can attract.

Butterflies and other insects may be captured gently and placed in a refrigerator for an hour or so. This does not harm them in any way, but it does slow them down. During this period you can select a plant or flower to be used as a prop, set up your camera and practise depth-of-field, composition and lighting. Now place the insect in position but work quickly, as you will have only a minute or two to get your pictures before the insect warms up enough to fly away.

Early autumn mornings are often misty, leaving grasses, leaves, spider webs and insects adorned with jewels. Insects which have spent the night exposed to the cold begin to move only after being warmed by the sun. It is possible to capture lovely photographs before they are freed of their dewdrops.

Dragonflies, found primarily in marshes and at lakeshores, are interesting photographic subjects. Their lives begin underwater, where they feed on mosquito larvae and other aquatic creatures. Later, a grass stem affords a stairway into the atmosphere, where they crawl out of their shells, dry their wings and begin to devour as many airborne insects as possible in order to satisfy their voracious appetites. Once airborne, the dragonfly will repeatedly use the same perch, which could be your outstretched finger. With patience you may well get a picture of your own hand complete with dragonfly.

Flowers

Even photographing wildflowers can have its hazards. In order to photograph a field of buttercups, Esther once chose a high knoll for a better angle. Within seconds, she was covered from head to toe in biting red ants. Needless to say, she quickly settled for a less dramatic viewpoint.

Particularly in spring and early summer, the park meadows abound with flowers of many varieties. Your fully automatic camera is quite capable of producing a lovely shot of a meadow filled with buttercups, dandelions or daisies.

The low-angle shot is excellent for single blossoms or clumps of flowers, and will show not only the flower itself but also the stems and leaves. "Houseclean" around the plant by removing any dead grasses or twigs. By throwing a shadow on the background, you can avoid a cluttered look by simply eliminating distracting grasses.

Avoid photographing two flowers on the same plane as your viewer's eye will simply wander back and forth. An odd number of flowers (one, three, five, etc) results in a more pleasing photograph. If you must have twins in your picture, move around to offset one from the other.

Once you've settled on your subject, take a reading from the grey card placed directly in front of the flower and open up one-half stop. If the flower and background are dark, you may have to open up one whole stop; if both are light in colour, it may be necessary to close your aperture down.

As it is important to photograph close-ups of flowers with a good depth-of-field, you should be shooting around f16 or f22. The wider aperture (f16) will "select focus" on the flowers only and blur a distracting background. The speed will be slow, so wait until the wind stops blowing before tripping the shutter.

With flowers, a close-up attachment or bellows will open up a whole new concept of photography. You will be able to get right into the heart of the flower and unravel its mysteries. Follow your close-up instruction leaflet carefully, especially regarding exposure, before attempting this kind of photography.

Remember that picking wildflowers not only endangers the entire plant, but that it is forbidden in the mountain parks.

PHOTOGRAPHING SCENICS

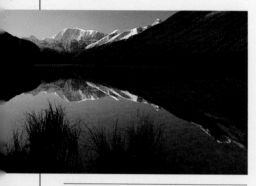

Photo 1: Mt. Rundle and Vermilion Lakes, Banff National Park, Alberta.

Photo 2: Mt. Kitchener, Jasper National Park, Alberta.

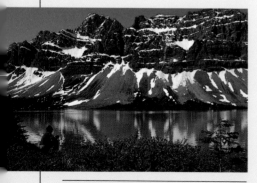

Photo 4: Bow Lake, Banff National Park, Alberta.

Most of our scenics are made with the 28 mm wide-angle lens to which a polarizer has been affixed. The polarizing filter is a fantastic little attachment. It will bring out the blue of the sky, enhance the clouds, add a deeper tone to flowers and remove the shine from water, leaves and rocks. Use a polarizer for added zip — except when a rainbow is present, as it will make the colors disappear. Autumn's splendor is enhanced by the use of a polarizer. *(photo 1)*

The automatic setting on your camera will usually handle scenics nicely, but where dark shadows or light areas predominate *(photo 2)*, it is advisable to take a reading with a grey card and go manual. With slide film, expose for the highlights as shown on the shots of Castle Mountain at sunrise. *(photo 3)*

Scenic shots, colourful or moody, can be lovely. Sunshine brings out the colours, water adds interest, blue sky adds appeal and soft white clouds can complete the picture. For a more moody picture, take advantage of fog, rain, snow, rays of sun and so on and expose for the highlights. Always have some centre of interest in your shots.

Open up your aperture to make snow appear white in

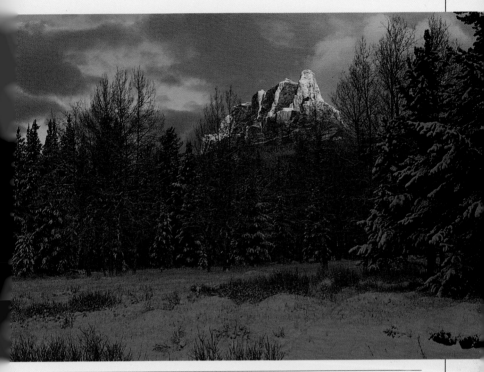

Photo 3: Castle Mountain, Banff National Park, Alberta.

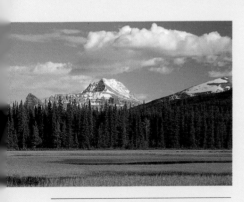

Photo 5: Mt. Sarbach, Banff National Park, Alberta

the finished photograph. If the aperture reading is f 8, open to f 5.6 for a more realistic reproduction.

Scenics are an excellent way to practise composition. Note the placement of the canoe, human figures and truck in these photos. (photo 4) They are positioned at or near one of the four corner junction points in the "Rule of Thirds" described earlier in this chapter.

Horizons should never be photographed across the centre of the frame (photo 5) unless, for some reason, you want your picture to show identical halves

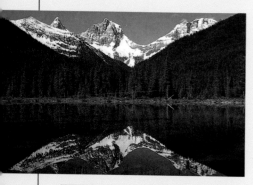

Photo 6: Mt. Verendrye, Kootenay National Park. B.C.

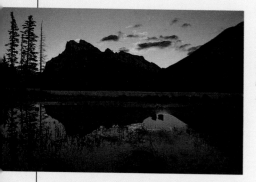

Photo 7: Mt. Rundle, Banff National Park, Alberta.

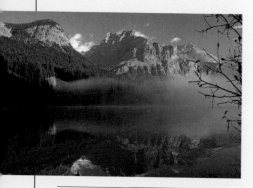

Photo 8: Emerald Lake, Yoho National Park, B.C.

as in the photos of Mt. Verendrye in Kootenay Park *(photo 6)* and Mount Rundle in Banff Park at sunrise. *(photo 7)* The photo of Emerald Lake in Yoho National Park is an excellent example of where the "Rule of Thirds" is successfully broken. *(photo 8)*

Dramatic scenes are expressed by verticals *(photo 9)* while horizontal formats *(photo 10)* invoke tranquility. Positioning mountain peaks *(photo 11)* and waterfalls *(photo 12)* near the tops of frames adds to the sense of majesty. Visual "frames," such as the one created by the trees in the vertical photograph of Vermilion Lake *(photo 13)*, can sometimes be an asset.

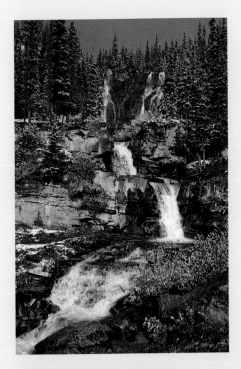

Photo 9: Tangle Falls, Jasper National Park, Alberta.

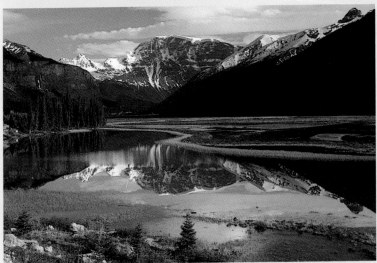

Photo 10: Mt. Kitchener at Beauty Creek, Jasper National Park, Alberta.

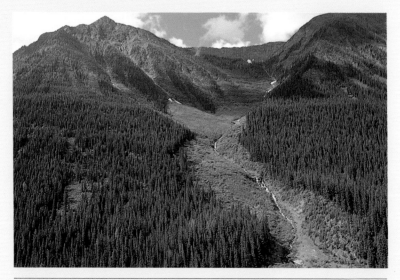

Photo 11: Mt. Numa, Kootenay National Park, B.C.

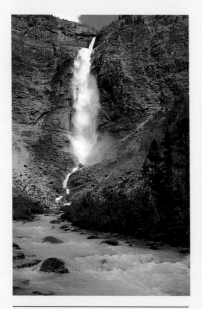

Photo 12: Takakkaw Falls, Yoho National Park, B.C.

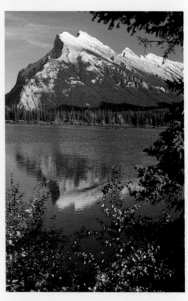

Photo 13: Vermilion Lakes, Banff National Park, Alberta.

Diagonal leading lines to your point of interest add a sense of adventure by taking your eye to the main theme. A good example of this is the sloping hill leading to the Prince of Wales Hotel located in Waterton Lakes National Park. *(photo 14)* A feeling of "being there" is achieved by incorporating interesting foregrounds such as flowers, bushes, rocks, and so on.*(photo 15)*

The photograph of the grizzly tracks in the snow is an example of telling a story with a photograph. As well as showing the size of the grizzly's feet, this photo gives some indication of the bear's habitat. The prints were left in the early morning hours, before the sun had a chance to melt the snow around them, and they emphasize the bear's direction and its leisurely pace. *(photo 16)*

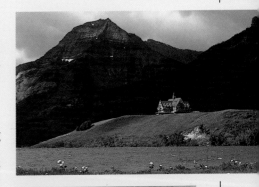

Photo 14: Prince of Wales Hotel, Waterton National Park, Alberta.

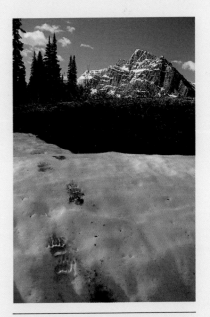

Photo 16: Grizzly tracks at Bow Pass, Banff National Park, Alberta.

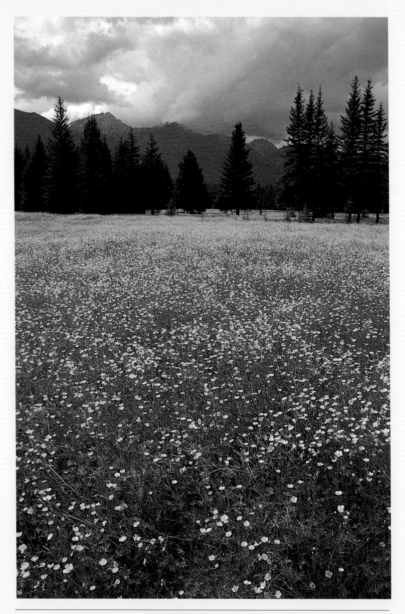

Photo 15: Western buttercup, Kootenay National Park, B.C.

CAMERAS AND EQUIPMENT

CAMERA SELECTION

Before embarking on any photography outing, you must get to know your camera and equipment thoroughly. Carefully study the manual and instruction booklets supplied with your particular camera. Spend a few hours checking each paragraph against your equipment. If your camera is not fully automatic, you will need to get to know what f-stops, shutter speeds and ISO (ASA) mean, and how to use them to your advantage.

Fully automatic cameras

If your camera is of the fixed focal length, completely automatic variety, your chances of getting close shots of wildlife, insects and flowers are rather limited and you may have to settle for habitat photographs. Habitat shots include some of the surrounding area or countryside, and can be very rewarding provided the main subject is large enough to be identifiable. In your enthusiasm to get a tighter shot, however, do not close in on wild animals: a close-up is never worth a physical risk.

Fixed focal length or automatic cameras of the Instamatic type adapt well to scenics, as their lenses lean toward the wide-angle shot. Look closely at the images in *National Geographic* magazine and you will discover that the greater percentage of the photographs were taken with a wide angle lens under subdued light conditions. In bright situations, with a light-coloured subject and background, include some dark areas in your photograph to correct for the camera's exposure.

Automatic plus manual action cameras

Some cameras have both automatic and manual features, which can obtain a wider variety of photographs than can a fully automatic camera. Such cameras may accept other types of lenses and your exposures with them can be more precise. Long lenses add intimacy to your photos.

If you are young and strong, then you are probably capable of hand-holding a long lens, but for others, like ourselves, some assistance is required to achieve a crisp photograph. When hand-holding, your shutter speed should be as fast or faster than the focal length of the lens you are using; i.e., a 100 mm lens should have a shutter speed of no slower than 1/125th second, a 200 mm lens no slower than 1/250th, and so on. When light conditions are not conducive to these speeds, use a tripod or other sturdy means of support to override body

movements and camera shake. (See the Aids to Photography section for more information on tripods.)

TECHNICAL OPERATIONS

F-stops

Depth of field is the sharp image depth within the picture itself. The closer the subject is to the camera, the shallower the depth of field; the farther away the subject, the greater the depth of field.

The aperture stops on many lenses range from f 2.8 to f 22, although others go up only as far as f16. Range of f-stops vary with different lenses. The higher the number of the f-stop, the greater your depth of field. F 2.8 enables you to operate in poor light conditions where the depth of field is very shallow; f 22 achieves the greatest possible depth of field. At f 2.8, only a narrow band of the photograph will be sharp. When using f 22, your entire photograph can be clear and crisp.

When photographing small objects such as flowers, butterflies and mushrooms, focus 1/3 of the distance into your picture. Set the f-stop at f 22 or the highest number on your particular camera, adjust your camera to cover light conditions by changing your shutter speed, and presto — a lovely sharp image will be your reward.

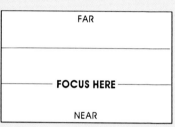

On larger subjects such as animals, a good basic setting is f 8, as this will give you sufficient depth of field. Focus on the subject itself: it is more important to have the animal sharp than the foreground or background. If there are two or more centres of interest in your picture, focus on the one closest to you as the mind will accept a distant blurred object before it will accept one in the foreground.

With scenics, study your instruction book to learn about the hyperfocal distance scale on your camera. This scale allows you to set the infinity sign [∞] opposite the f-stop you are currently using, to arrive at the distance in front of the camera that will be sharp right through infinity. If you follow this method on scenics there will be no annoying fuzzy band along the front of your pictures. When using the highest f-stop numbers such as f16 or f 22, use a tripod or other firm support, along with a cable release, to eliminate camera shake.

Shutter Speed

Subjects in motion blur when the shutter speed is too low; the higher the camera shutter speed, the clearer your photographs of moving animals will be. A high shutter speed, however, allows less light into the camera than a lower one, so light conditions must be taken into consideration as well. Camera shutter speed is marked in parts of a second, and must be synchronized with your f-stop. This is quite simple once you get the hang of it.

On a clear, sunny day, your camera may be set at f 8, with a shutter speed of 1/250th of a second. Suddenly a cloud comes over the sun. Now you must adjust either the f-stop or the shutter speed, depending on whether you prefer the greater depth of field for stationary subjects such as scenics, mushrooms and so on, or the speed for moving wildlife. For stationary subjects stay on f 8 for greater depth of field, but drop the shutter speed to 1/125th of a second. If you want the speed, f 8 now changes to f 5.6, allowing more light to reach the film. The heavier the cloud, the more you must compensate.

For an accurate reading on light conditions when using a camera which is not totally automatic, use a light meter or a gray card, available at any good camera shop; these can eliminate much of the guesswork and frustration of photography. The gray card is designed to be used in conjunction with your camera's built-in metering system. (For more information on meters and gray cards, refer to the Aids to Photography section.)

ISO (ASA) setting

All photographic film is affected by light and is available in various degrees of sensitivity. This is the ISO rating. Lower ratings (ISO 25, for example) indicate film with slower light gathering ability and finer grain, resulting in sharper images. The higher ratings (such as ISO 1000) identify faster light-gathering ability. This film allows you to operate under poor lighting conditions, but produces reduced quality of image.

The ISO setting on your camera is an important factor in achieving excellent results. Although the more sophisticated models of camera set the ISO automatically, most require that the operator be responsible. Unless the ISO is synchronized to the film in your camera, the results could be disastrous. One enthusiast spent six months touring Europe and Asia, using over 100 rolls of film. The film happened to be ISO 100; the camera was set at ISO 25. The result? All of the photographs were overexposed and useless. In this case, a little knowledge could have saved a lot of heartache.

USING YOUR CAMERA

Once you understand the technical operations of your camera, the next step is to go outside and practise. Before you first insert film, you can practise your depth-of-field using different f-stops, practise framing your picture to achieve a more pleasing image, get down on your knees or your belly for a different angle, discover what backlighting will do, and so on. Understanding your camera and what it can do for you will greatly increase the pleasures of photography.

Now you must select the film you prefer to use. Slide film includes the word "chrome" in its name; print film is denoted by the use of "color" in the brand name. We have found that Kodachrome 64 offers sharpness for scenics, as well as speed for wildlife, and it has worked well for us over the years. Other photographers may prefer other brands, and you can find your own preference by experimenting with different types of film.

When you first insert film into your camera, ensure that it has caught on the sprockets. If it does not catch, you could shoot away for hours without advancing the film, and lose a number of splendid images. Test for connection by gently turning the camera's rewind knob: if it becomes tight and will not turn, you have installed the film properly. If it does not, open up the back of your camera and start again.

When you are satisfied that the film is in position, advance it a couple of frames by tripping the shutter. This will eliminate any light streaks that may have occurred on the first two frames during loading. Always load and unload your film away from direct sunlight to prevent a flare on your picture. Never leave your camera on the dash board, in the glove compartment or in the trunk of your car, as the heat will damage the film.

Your camera is now loaded with the film of your choice, and it is time to take a test roll of photographs. In a notebook, keep records of light conditions, time of day, the f-stop, the ISO, and the shutter speed you've used on every frame. Expose the entire roll and send it off to the processors. When you get the results back, check the pictures against your notes and revamp your thinking if something is not quite right.

The ISO, the aperture setting and the shutter speed are closely interrelated, and practice and note-making will allow you to gain an increasing awareness of this critical series of relationships. Lens length, camera shake and subject movement will also affect the quality of your photos, and you may want to make note of these factors as well. Studying popular photography magazines can give both ideas and inspiration to help you improve your photographs.

AIDS TO WILDLIFE PHOTOGRAPHY

The following devices and attachments have proven useful to us in creating successful wildlife photographs.

BLINDS

We use two types of blinds.

One, a tent-type structure covered with camouflage nylon fabric, is used for long term projects wherever the subject is almost guaranteed to remain in one place for a reasonable period. These subjects include birds at their nests, and animals near their burrows or dens. This blind is excellent except for one thing: your vision is restricted to a small opening through which you poke your lens.

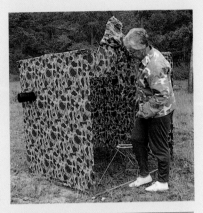

A home-built 2-person blind.

The other blind, our favourite, is simply a special, almost weightless blanket sporting multitudes of slashes. It measures 1.5 x 2 m, weighs but a few grams, fits into a large pocket, is reasonably cool, camouflaged, very effective, and goes by the trade name of Duckman. When you throw this blanket over yourself and your camera you just — disappear. The Duckman offers a good view of the entire area.

Blinds need not be anything fancy. A worn-out many-coloured bedsheet or tablecloth secured around yourself and your camera equipment works well, and can be manipulated to expose your eyes for viewing. This kind of blind allows you to move quite freely from one position to another. Trees, shade, tall grasses, reeds,

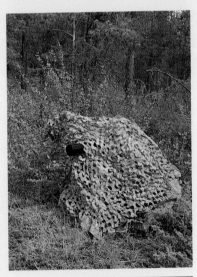

"Duckman" blind in use.

A reed blind.

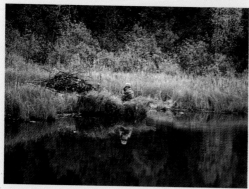

A canoe blind.

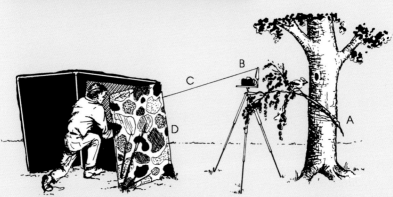

A. Interesting looking branch tied firmly to tree trunk near nest cavity.
B. Camera on tripod with remote control device.
C. Pull string.
D. Camouflage blind or small tent.

A PHOTOGRAPHER WORKING IN THE FIELD

brush, fallen logs and old buildings afford sufficient additional cover in many instances, provided you remember to stay upwind from the animal and to move as little as possible. Such a blind can be successfully used on a well-travelled game trail (especially those close to water holes) during early mornings and evenings.

We have even been known to use a large cardboard shipping case as a blind in instances when it was imperative that the subject get used to a foreign object for several days before we moved in with our equipment.

Multi-coloured clothing and camouflaged equipment helps lessen the stark human image and often is all that is required. Small commercial tents are not very efficient blinds as the solid colours create a bold outline in the woods, which can act as a warning to wildlife. Also these tents can be hot, and one's viewing is severely restricted to the small area directly in front of the opening.

A word of caution: do not use an inflated tire tube in conjunction with chest waders as a floating blind. Should the tube be punctured, the waders could fill with water and escape would be impossible. Dennis had the frightening experience of an almost new inner tube rupturing soon after leaving a deep marsh. If necessary, rigid expanded foam flotation boards could supply the required buoyancy for a safe return. Our canoe, covered with reeds and grasses, has given us excellent coverage on lakes and marshes.

The Inuit hunt by holding a frame-type blind in front of them when approaching their prey. Perhaps this could be adapted for photographers in certain situations, but it does not seem very practical in the mountains.

When you wish to photograph animals spotted along the roadsides, your vehicle will act as a very efficient blind, especially in the mountain parks where the wildlife is more used to vehicles.

A blind is simply a place of concealment, so use your imagination as no two situations are alike.

STABILIZERS

Tripods

A good sturdy tripod is a must when photographing in low light conditions, or when shooting with long lenses. Small, usually cheap, tripods which fold up into very small packages are not usually very solid. A good tripod has no more than three sections (two are better) to reach its maximum height.

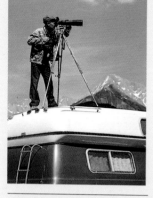

Using a tripod allows you to gain a greater depth of field by using a smaller aperture opening, and it eliminates camera shake. It will also improve your composition, as you need worry only about your subject and not about steadying your camera. Use a cable release and keep your hands off the tripod when exposing your picture to ensure a clear, crisp image.

Although the tripod is by far the best camera support, by propping your camera against your vehicle, a rock, a building or even a tree and holding your breath during the exposure, you can achieve excellent results.

"Shooting" atop our camper.

You can create a makeshift tripod by forming a teepee of dead branches, tying the tops together with string, and placing your camera in the crotch.

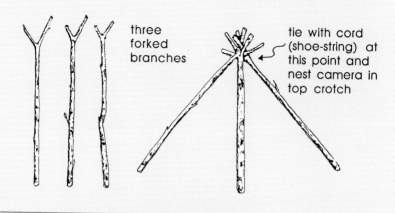

three forked branches

tie with cord (shoe-string) at this point and nest camera in top crotch

EMERGENCY TRIPOD

Window Pod

This homemade metal clamp fits snugly over the body of the camper or car, at the base of the window. An ordinary tripod head screws onto this device, thereby offering the advantages of a tripod without requiring as much space. Any lens, including the 800 mm, can be used from this firm mount.

Bean Bag

The simple bean bag, made from any tough fabric and filled with one or two kilograms of beans, makes an excellent emergency tripod. This can be instantly placed on the window ledge of your vehicle, saving many precious moments. Any lens up to 200 mm may be used effectively on a bean bag.

You can also use the bean bag in flower photography. By placing the bag on a rock or a stump or even on the ground as a firm support for the camera, one can obtain photographs taken from very close to ground level. Again, use your cable release to avoid camera shake.

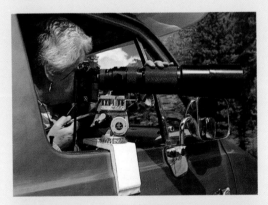

Window pod in use.

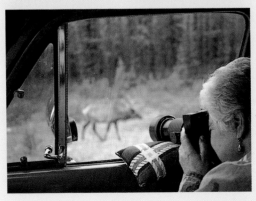

Bean bag in use.

ACCESSORIES

Cable Release

While using your camera on a tripod, a cable release or remote control cord (to operate the camera shutter) is important for vibration-free exposures.

Motor Drive

A motor drive, or "winder" as it is sometimes called, is essential when using a remote control of any kind: whether it be a release cable, an extension cord or a radio remote control. The motor drive is an asset for action shots, as the film is automatically wound after each shot and readied for the next exposure, allowing one to take more frames per second than would otherwise be possible.

When we are filming, our motor drives are constantly on "ready." They may be set on either "single sequence," which enables us to choose the point at which to trip the shutter, or "continuous," in which case the camera automatically exposes at four frames per second. We prefer the single sequence setting for more intimate results.

Flash Units

Many times we have found good subject material in poor or shaded light conditions; the flash unit has made splendid photographs possible. It is worthwhile noting that flash use restricts camera shutter speeds, usually to 1/60 or 1/125 or slower. There are three types of flash unit:

Manual flash All electronic flash units have an exposure dial, which is not connected to anything. These employ a dial guide system, with which you manually set your ISO (ASA) and the flash-to-subject distance, and the indicator tells you the correct f-stop (aperture measurement). You may also measure the amount of light at the subject with a flash meter. In both cases, you then set your f-stop accordingly.

Dedicated flash Flash photography has been simplified in the newer single lens reflex cameras by the insertion of a metering cell into the camera itself. Incorrect exposure is avoided, as the cell measures the brightness and automatically adjusts the flash output. The word "dedicated" generally indicates that the flash has been developed for a particular camera make and model.

Automatic thyristor-controlled electronic flash You set your lens f-stop to coincide with the distance scale on the flash unit. The sensor cell on the front of your flash will measure the light reflected by your subject, and automatically control the amount of light emitted by the flash, to ensure correct exposure.

Bellows, extension tubes, and close-up lenses

These devices, which allow the photographer to move close to the subject while maintaining a sharp focus, are essential for photographing small objects. These accessories will produce a larger image than a normal lens at its closest focusing distance. The bellows and extension tubes are mounted on the camera before the lens is mounted, while close-up lenses are placed in front of the mounted lens, with the highest numbered optic closest to the lens.

Light meters and gray cards

All photographic film is affected by light and is available in various degrees of sensitivity to light (identified by the ISO rating). The general rule is, the slower the film, the finer the grain of the image. Lower ratings (ISO 25) indicate film with less light-gathering ability and finer grain, and these give you sharper images. The higher ratings (ISO 1000) indicate faster light-gathering ability, which allow you to operate under poor light conditions. With these films the image quality is greatly reduced by the size of the silver grains making up the image.

To adjust the lens so the correct amount of light reaches the film for correct exposure, the light must first be measured or evaluated. This is the sole purpose of the light meter.

There are two kinds of meter — incident and reflected light — and there are basically three types of reflected meters:

Fully automatic meter This is built into the camera body, making exposure adjustments automatically.

Built-in metering system As the camera is pointed at the subject, a built-in metering system calculates the f-stops and shutter speeds. This information, displayed in the viewfinder or on the meter scale, must then be transferred manually to the camera by the operator.

Hand-held meters Separate hand-held units calculate the f-stops and shutter speeds. This information must then be manually transferred to the camera's controls.

Spot meters Most reflected light meters have an "acceptance angle" (the area viewed by the meter) of approximately 45°

(equivalent to or a little wider than that seen by the normal lens), and they evaluate the light as if coming from a subject of "average" reflectance. A spot meter is an exception. It has an acceptance angle of about 1°, which enables the photographer to take a direct meter reading on a very small portion of the picture. This is very useful when photographing dark or light subjects surrounded by distracting backgrounds or foregrounds.

Having set the meter to match the film's ISO rating, point the meter cell directly *at* your subject in order to receive a "direct" reading of the light being reflected *off* the subject.

Flash Meters When using a flash meter to evaluate the light delivered by an electronic flash unit, the same instructions apply except that readings must be made from the location of the subject or from an equivalent distance with the meter pointing back towards the camera.

Incident meters The incident meter allows you to take accurate light readings of the light falling on the subject rather than reflected off the subject. This is especially useful with unusual and backlit subjects. Most professional light meters come with an incident dome which is a translucent plastic dome that can be placed over the meter cell to take incident meter readings.

With the dome in place, stand at the subject position and hold the meter so the dome and the meter cell point back towards the camera. The pattern of light and shadow that falls on the cell will then be similar to that which would fall on the subject as seen from camera position. The meter will give an accurate reading independent of the brightness of the subject.

It is also possible to take an incident reading from the camera position. In the same manner as before, hold the meter so that the cell faces towards the camera in the same direction as if at the subject position. The light at your position must be the same as the light at the subject position for this technique to work.

Gray Card An excellent aid to the photographer, an 18% gray card simulates "average" subject reflectance for photography.

The gray card must be used in conjunction with a light meter, either built-in or hand-held. Aim your meter at an 18% gray card, making certain that the angle from the camera to the subject is the same as the angle of the meter to the gray card. The light falling on the card must be of the same value as the light falling on the subject.

Used properly, the gray card and meter combination will give excellent results. Remember to adjust your aperture for either more or less light if the subject requires. If the subject is dark and large in the frame, for example, open up your aperture.

HOME-MADE REMOTE CONTROL DEVICE

Photographers who are short of equipment can easily make this simple device from workshop scraps.

The 12.5 cm plywood base is larger than the camera body, to accommodate any weights that may be necessary to hold it firmly in place when a tripod is not in use. For mechanical advantage, the shutter trip lever should be 12.5 cm by 5.5 cm. The size of the other parts depends on the size of your camera.

If your camera is not equipped with a tripod screw hole on the base, heavy elastic bands or strapping tape can be used to secure your camera to the remote control device. Do not obstruct any moving parts or the lens.

Make certain that the base mounting screw is not too large, as forcing it into the base could damage your camera.

Attach a long string to the top end of the lever.

After focusing on the area where your subject will be, cover the camera's eyepiece with a piece of electrician's tape. On single lens reflex automatic cameras, if any light should enter the eyepiece from behind, the exposure will be severely altered as the light reaches through the eyepiece and into the lens itself. Film fogging can also be a danger, especially in older cameras.

With trip string in hand, retreat to your hideaway blind and you are in business. Good luck!

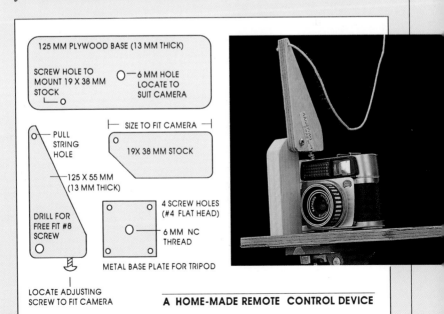

125 MM PLYWOOD BASE (13 MM THICK)

SCREW HOLE TO MOUNT 19 X 38 MM STOCK

6 MM HOLE LOCATE TO SUIT CAMERA

PULL STRING HOLE

SIZE TO FIT CAMERA

19X 38 MM STOCK

125 X 55 MM (13 MM THICK)

DRILL FOR FREE FIT #8 SCREW

4 SCREW HOLES (#4 FLAT HEAD)

6 MM NC THREAD

METAL BASE PLATE FOR TRIPOD

LOCATE ADJUSTING SCREW TO FIT CAMERA

A HOME-MADE REMOTE CONTROL DEVICE

MAMMALS

BLACK BEAR *Ursus americanus*

Although its common name is "black bear," this animal is not always black. Its wide assortment of colourations ranges from black through various shades of brown, into even a delicate cream.

Bears fatten up in the fall for the winter's rest inside sheltered dens, where they can avoid the cold and lack of food. Theirs is not a true hibernation, but rather a deep sleep from which they awaken periodically, to leave the den for a stretch. Upon their final awakening in the spring they are lean and hungry, but their keen sense of smell will guide them to the carcasses of animals that failed to survive the winter. The new growth of roots and bulbs is also on the menu in the spring.

Every two years, during the denning sleep in January or February, and after a gestation period of about seven and a half

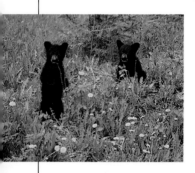

months, the sow will usually give birth to two cubs weighing approximately 225 g each. These grow quickly on her rich milk until it is time to leave the den. Black bears climb trees with ease, and when danger threatens, the female will send her cubs high into the trees, where they will remain until she gives the signal that it is safe.

It is an awe-inspiring sight to see a bruin standing on hind legs, as a human does, surveying whatever may offer a threat. A mature black bear male will reach a weight of approximately 270 kg, while a female will weigh about 160 kg. Life expectancy is 20 to 30 years.

This bear roams freely throughout our mountain parks. Many sightings occur in the first two weeks of June between Saskatchewan Crossing and Mount Cirrus, as well as at Jasper's Jonas Creek area. At this time, one of the black bear's favourite foods, the dandelion, is in full bloom.

Bears demand a lot of respect as they are very unpredictable: especially when young cubs are present. It is wise to admire at a distance and photograph with a long lens.

Black bears are particularly hard to photograph successfully. Remember to compensate for their dark coats: if the bear is large in your frame, open up your aperture. The larger they appear in your frame the more you must open up — as much as two stops in some instances. Try for a low angle to get a light in the eye.

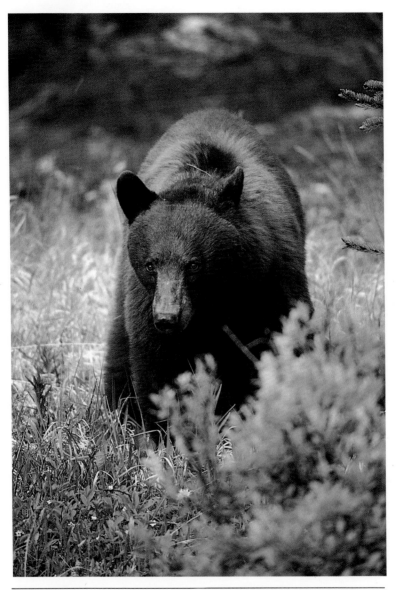

Park bears are not always amicable and they can be very aggressive. This brown-phase bruin was in a cantankerous mood one morning and let it be known that he was in no frame of mind to be tampered with. The back hairs were hackled as he charged the sound of the camera several times: a good example of the wisdom of remaining in the vehicle when photographing bears.

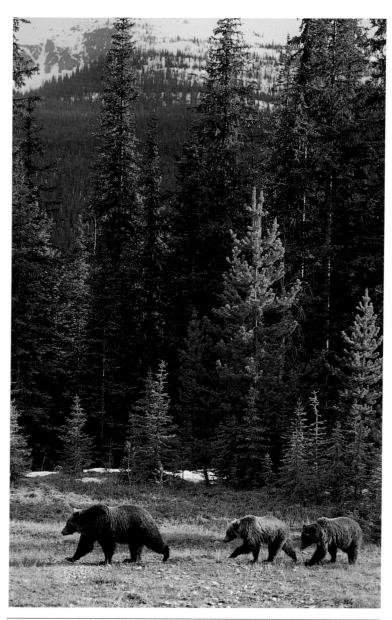

A sow with cubs searching a better food supply in the Bow Pass.

GRIZZLY BEAR *Ursus arctos*

The grizzly is one of the most impressive mammals living in the Canadian mountain parks. The most opportune times to catch a glimpse of these magnificent animals are late May, at Bow Pass (Banff Park), when the bears have just come out of hibernation, and again in the autumn before they den up for the winter. During the summer this bear prefers the high country away from civilization: the grizzly is essentially a loner, requiring lots of space and privacy.

A very distinctive, powerful animal having a massive head and a round build with a large hump on its shoulder, the grizzly is much larger than the black bear. A male can weigh up to 545 kg, a female 455 kg. The claws of a grizzly can grow to 12.5 cm in length and its huge paws can overturn, in one swoop, a large boulder that would be difficult for a man to lift. They have a short temper and must be respected at all times, especially if at a kill or with cubs. The grizzly is extremely fast when agitated and can easily outrun a horse. It prefers not to climb trees due to its heavy body and long claws, but has been known to shake its prey out of a tree.

Like the black bear, the grizzly enters a period of semi-hibernation during the winter months. Every second year the female gives birth in January or February, usually to two cubs weighing approximately 500 g each.

After the grizzly emerges from the den in spring its front claws, having grown long from disuse, are well prepared for digging roots such as springbeauty (the "wild potato" - *Claytonia*). The first growth of the horsetail (*Equisetum*) forms part of the spring diet, as does grass. *Hedysarum* roots, being highly nutritious, are an important food source for grizzlies in the spring and the autumn, when the plant is dormant. Although the grizzly has a varied diet, it prefers that the largest portion be vegetation.

Search open meadows and open slopes for sightings of the grizzly, always from the security of a vehicle.

Sows and cubs often spend idle hours confirming the bond between them through play. Due to the action and poor light, we chose the 200 mm lens wide open at f 2.8 on automatic.

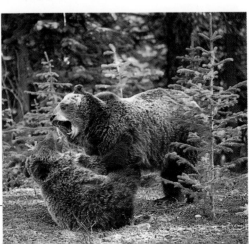

MARTEN *Martes americana*

An old woodpecker's hole or hollow log affords satisfactory sleeping quarters for the marten during winter months. On warm summer nights a high tree branch will do, but the marten's favoured place for raising a family is a hollow tree lined with leaves. The young (an average of two to four) are born in the spring, and leave the nest at around three months to take up the solitary existence which is characteristic of the species.

The marten has two scent glands. In addition to the anal gland, the belly holds one that leaves a distinct trail as the animal travels along tree branches. You may get a whiff of this beautiful creature without ever seeing one.

An evergreen forest dweller, this small carnivore will hunt day or night depending on what food is available. Its favourite prey — mice and voles — are nocturnal, but if it fancies a squirrel, it will race through the treetops in daylight. A few insects, snakes, birds' eggs and berries add variety to its diet.

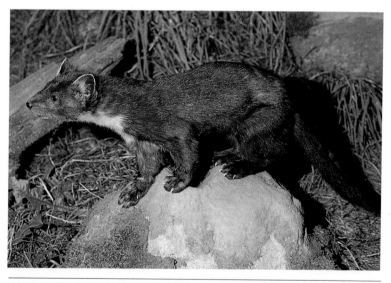

Above: Curiosity left no nook or cranny unchecked in this marten's search for food. The photo was taken at Lac Beauvert in Jasper National Park, with a 200 mm lens.

Right: To capture this portrait in the deep shade of the forest, we used a 200 mm lens with electronic flash and remote control.

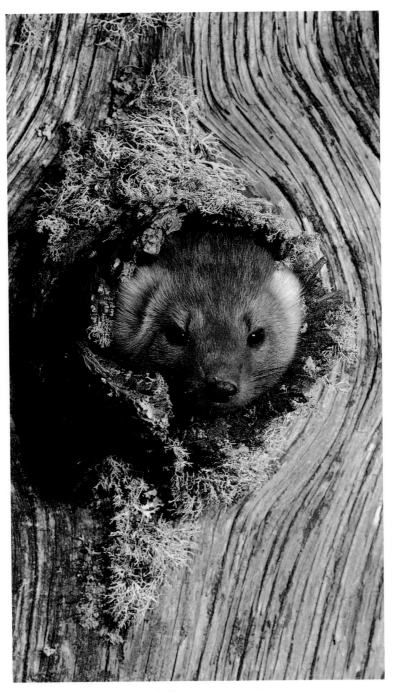

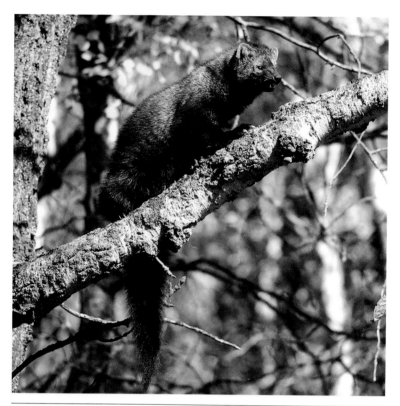

A rare opportunity was granted us when we came across a fisher just after it finished a dinner of grouse. The animal, relaxing in the sunshine, was in no hurry to leave. Using an automatic exposure, and by propping our 400 mm lens against a nearby tree, we were finally able to capture a fisher on film.

FISHER *Martes pennanti*

The fisher's name is a puzzle, as this mammal does not fish. It is a shy animal, and sightings are rare.

The fisher is a close relative of the marten, although it is much larger. Male martens are approximately 65 cm long and weigh just over 1 kg, whereas male fishers can be up to 100 cm in length and weigh up to 5.5 kg. Despite the size difference, this speedy predator has occasionally been known to chase and capture a marten.

Fishers prey on animals such as the snowshoe hare and the porcupine. The fisher technique with porcupines is to attack the face and throat, which are devoid of quills. This method is so effective that trapped-out forest areas with an overabundance of porcupine are currently being restocked with fishers by wildlife management, in order to reduce the destruction of trees.

WOLVERINE *Gulo gulo*

Resembling a bear, this giant solitary weasel is an ideal example of a wilderness inhabitant. With his steady lope, the wolverine can cover forty-eight kilometres a day in quest of food. Nothing is too large or too small to be considered prey. Moose and elk are sometimes taken when a wolverine leaps onto the back of one of these large mammals from an overhead branch. Smaller quarry afford no problems, and even rotted carrion is considered a delicacy. When his meal is finished, the wolverine will cover the carcass with an exceptionally strong odourous substance excreted from his musk gland, to discourage other predators from enjoying the spoils.

This predator, weighing approximately twenty-three kilograms, is a fearless fighter and has an endurance outlasting that of most hunters. Aside from an occasional wolf, it has few natural enemies.

Mating occurs from April through August. The gestation period of nine months results in two or three young which are born in a remote, natural cave or shelter. Around six weeks they are weaned, fed regurgitated food and taught the specialized art of being a wolverine by the female, as the male's only responsibility is to breed.

The most likely places to find this ever alert, rare animal are Bow Pass, Helen Lake and the Dolomite Pass areas, although they are very rarely seen. Once, we were thrilled to witness a wolverine sitting upright, shielding his eyes with a front paw (sailor fashion), watching our every move from a distance. Unfortunately, he was too far away to photograph.

Facing page: The smellier the carcass, the better the wolverine enjoys it. This fearless creature did not consider humans a threat, although he made it clear that he would not tolerate our coming too close. We stayed well out of his way, working with a telephoto lens.

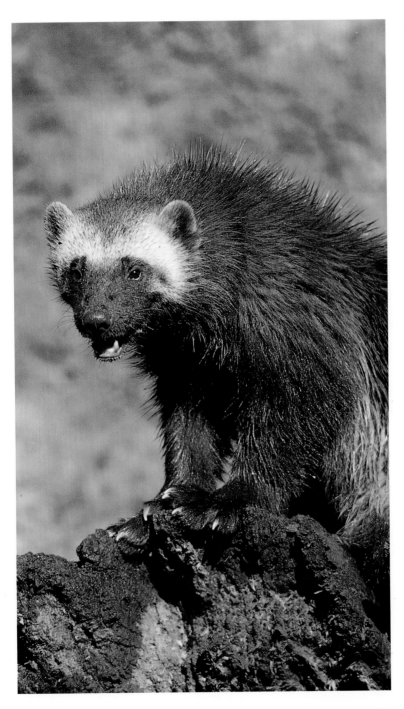

BADGER *Taxidea taxus*

Although the badger can be ferocious in attack, he prefers to avoid a fight. When approached, he will raise himself, fluff his body to an enormous size and snarl, spit and growl fiercely; all the while backing up or charging in short spurts. By keeping our distance, we have followed him until he has quieted down enough that we could obtain the photographs we wanted. One actually crept under a tree during a photo session and went to sleep.

Badgers are squat, pigeon-toed, solitary, sturdy, 8 to 9 kg carnivores of the valleys and plains. Their greatest love seems to be digging for food and shelter. Being wanderers, they sometimes need to dig a new den every day. A principal exception to this pattern is the period spent in the natal den, where the female alone cares for the cubs for a period of perhaps three to four weeks.

The natal den is up to two metres deep and is usually located in a dry, remote place far from civilization. As the cubs (usually four) mature, the female introduces them to the hunt, which is usually done at night, and to the ways of badger survival. Once outside the natal den, the cubs are unlikely to return.

With their extremely long claws, badgers are able to ravage the dens of ground squirrels and rodents within minutes. Badgers and coyotes sometimes hunt in tandem. As the badger digs, the coyote will share in capturing the spoils. As the coyote wanders, spooking ground-nesting birds or mice, the badger enjoys an easy meal. Both animals are real opportunists.

The open prairie on the east side of Waterton National Park is prime badger habitat.

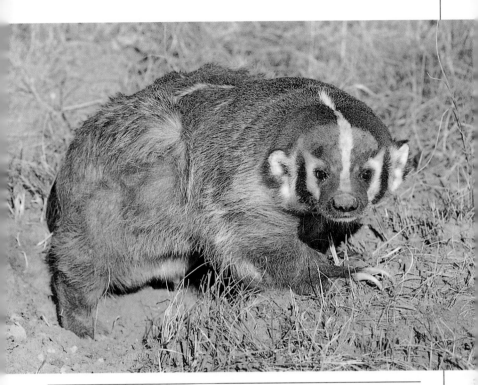

This fellow was so busy enjoying his favourite sport of digging for ground squirrels that he did not notice our approach. One of our team photographed with the hand-held 200 mm lens, while the other held the badger's attention to keep him in the area. We used an automatic exposure.

COYOTE *Canis latrans*

With North American Indians, the coyote held a place of honour. The animal's mental abilities seemed so far superior to those of other mammals, birds and even humans that it seemed a supreme being was guiding the wild dog's thoughts and actions.

When non-native cattle and sheep ranchers arrived in the West, they feared the coyote's attacks on young herd animals. They used poisons, traps and guns, but every attempt to exterminate the coyote failed. The invincible coyote continues to thrive: perhaps confirming the ancient beliefs.

This highly adaptable wild dog does an admirable job in reducing populations of mice and insects. Berries in season are a special treat but coyotes seem to eat anything digestible.

Five to ten pups are born within a deep, secluded den during April or May. Rich milk will fatten them, then both parents will hunt, hold the undigested food in their stomachs, return to the den and regurgitate to feed their ever hungry offspring. The pups grow rapidly. At about six weeks, they are out with their parents.

Communication is a big part of survival, and coyotes will follow a flight of ravens or magpies to guide them to the carcass of an animal which could supply food requirements for days. They share the spoils by calling other coyotes to join the feast. It is exciting to hear the yapping call of the coyote, especially when several respond from different directions at the same time.

Any open meadow in the mountain parks is coyote habitat. They blend well with the surroundings and are sometimes difficult to see.

It is unlawful to feed these animals or any other wildlife in the parks. Their fear of humans is reduced with contact, and they can become very aggressive when denied.

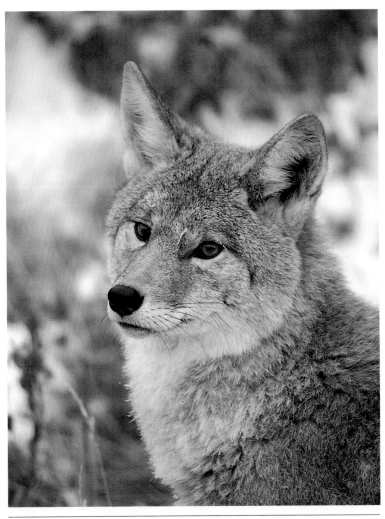

One chilly, frosty morning we came unexpectedly upon this beautiful coyote in the act of catching mice for breakfast. The light was too low for action shots, but several times he would pause to sit, watch and listen for the elusive mouse. Making use of our camper as a blind, we mounted one camera on the window pod and set the other on a tripod at an upper window. To achieve correct exposure, we constantly checked the light value falling on the subject with a hand-held meter. This portrait was taken with a 500 mm lens.

GRAY (TIMBER) WOLF *Canis lupus*

The elusive wolf is the largest member of North America's wild dog family, with males standing approximately 70 cm at the shoulder, and weighing up to 55 kg. The gray, or "timber," wolf is a beautiful animal, usually grayish brown but varying from almost pure white to black, with remarkable yellow eyes.

A pack consists of up to a dozen animals with an Alpha leader (usually male) and its mate at the top of the hierarchy. Only the Alpha pair is allowed to mate and will give birth to six or seven pups in a deep, underground den during early spring. Growth is very rapid on mother's milk at first, later supplemented with fresh meat. All members of the pack take part in caring for the pups. In seven to ten weeks, the pups are ready to take lessons in hunting strategy.

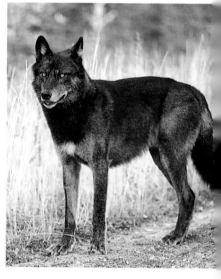

As winter approaches, the wolf's fur thickens, enabling the animal to withstand temperatures of minus 45 degrees or more. The wolf is a selective hunter, preferring to take the weak and sick of the deer family. Rarely do wolves eat other than their own kills. If the hunt is successful (and only one in ten are), the whole pack will gorge themselves, then remain near the kill until the entire carcass has been devoured. Their summer diet is varied, consisting of smaller animals, ground nesting birds, berries and fruits.

Hearing the hauntingly beautiful call of the wolf is a true wilderness experience, especially when you are near a campfire in the moonlight. Join in the chorus — they will respond.

This shy animal is not the "big bad wolf" of fairy tales but rather a gentle, loving creature that has been misunderstood for centuries. We have had the privilege of meeting them several times in the wild and have felt nothing but admiration. There is not one proven case of a healthy wolf harming a human in North America.

Keep a close watch for them in the mountains, especially between the East Gate of Banff National Park and throughout the lower valleys.

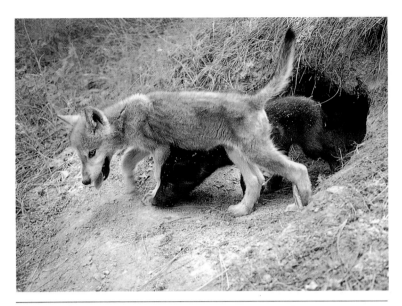

Above: Wandering through wolf territory one day, we stumbled onto a den. Not wishing to disturb the tranquility of the scene we stayed just long enough for a few quick shots with our 200 mm f 2.8 lens before moving on.

Facing page: While hiking a deserted road, we were conscious of a wolf following off to one side. We practised our wolf calls and were rewarded with its coming to the road shoulder and singing for us. After a few photos, Dennis decided to submit himself to this fascinating animal by lying flat on the ground. The wolf immediately dropped his ears, slowly wagged his tail and approached to within five metres. There he stood for a few moments just watching Dennis before sauntering back into the woods.

RED FOX *Vulpes vulpes*

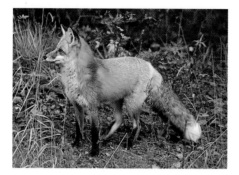

Sharply alert to the chipping of a squirrel, this beautiful specimen permitted us to photograph with a 50 mm lens. We used incident reading due to the dark background.

A magnificent, resourceful and secretive member of the wild dog family, the normally nocturnal fox will hunt any time when hungry. Mice, voles, hares and rabbits are its mainstay, with carrion, insects, birds and berries being acceptable alternatives. Grouse are taken with cat-like accuracy. After ingesting its fill, the fox will bury the remainder of the catch for tomorrow's meal.

In Canada, the red fox ranges from the United States border as far as Baffin Island in the Arctic. There are three basic colourations: red, cross and silver. All three have distinctive black legs, black feet and a white tipped tail.

Four to nine dark brown pups are born in April after a gestation period of approximately fifty days. Foxes are very attentive parents: both adults feed and foster the young. Pups emerge from the den at about four weeks to soak up the sunshine and frolic with toys of sorts: a feather or a piece of old hide is common. The natal den is often moved (probably for sanitary reasons) to a second site when the pups are approximately seven weeks old. They soon join the adults to learn the ways of the hunt.

In September the pups, now capable of fending for themselves, strike out to establish territories of their own. The adults also separate for a winter of solitary hunting.

One autumn day we shared a remarkable experience with a little fox. After we'd spent many hours in its territory, one became so unafraid that it allowed Esther within two metres, and then lay down behind some short grasses. Curious as to what he would do, Esther slowly lowered herself to the crawling position and quietly approached the animal. The fox actually permitted Esther to remove the grasses, which were only a couple of centimetres from its eyes, and photograph with the normal 50 mm lens.

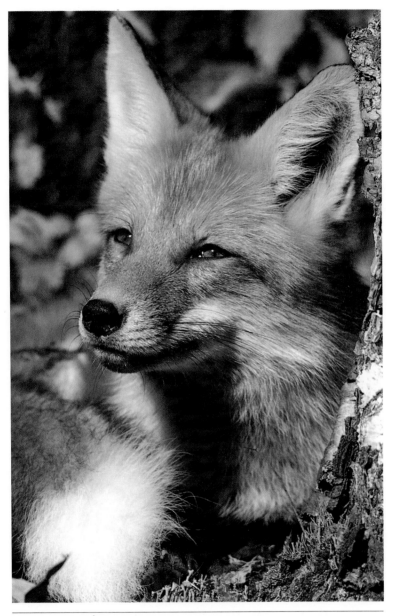

By zooming in, you can achieve a fine portrait without chang-
ing your lens or your position. Our lens was set at 500 mm in
this case.

MOUNTAIN LION *Felis concolor*

"Puma," "panther" and "catamount" are names applied to this magnificent cat in various parts of the Americas. Here in our mountain parks it is called "cougar." At one time this animal ranged from coast to coast throughout the northern boreal forest, British Columbia, Western Alberta and on into South America. Human expansion has forced the cougar into the few remaining wilderness regions and protected areas, such as the parks.

Weighing up to 100 kg, this is the largest North American wild cat and carries the longest and heaviest tail, which it uses for stability, of all the cat species. A lone and secretive hunter, the cats range throughout the parks where a constant food supply of deer and elk is assured. As with all cats, the cougar stalks its prey. It can leap six metres from a standing start to its victim's head and neck.

Being chiefly nocturnal and shy of humans, it is rare for anyone to sight these large cats. Groups of ravens or magpies circling overhead or perching in a particular area may be an indication of a carcass nearby that has attracted such a predator. From an inconspicuous vantage point high in a tree, the cougar will often keep guard over a kill until its hunger has been satisfied.

The scream of a mountain lion at night is not likely to be forgotten. Not only is this animal wild in every sense of the word, it is also awe-inspiring, and hauntingly beautiful.

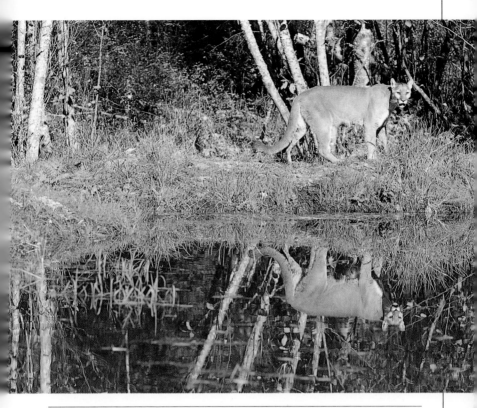

Recent tracks in the mud alerted us to the possibility of a female cougar's returning to the beaver pond with a kitten, for a drink or a meal. We selected a spot from a distant rock bluff, making sure the wind was in our favour, and covered ourselves with the "duckman" blind to wait. It wasn't long before our hopes were rewarded as the two did return long enough for us to get a couple of quick photos. Our motor drives are kept on the cameras, ready for action at all times, but in this case we preferred the quieter operation of the manual shutter. We used the 200 - 500 mm zoom lens.

LYNX *Lynx lynx*

Somewhat larger than its close relative, the bobcat, the mature lynx has a body length of 85 cm to which is added a 10 cm, black-tipped tail. The longer legs and oversized feet of the lynx adapt it well for hunting the snowshoe hare, its chief source of food, in deep snow.

When the hare population peaks, every nine to ten years, the lynx will produce a litter of up to four kittens. When food is scarce, however, during the hare's low cycle, fewer females mate and the litters of this shy, solitary night hunter are smaller.

This beautiful cat is widespread throughout the mountain parks' boreal forests, but is seldom seen. Its call is more like a canine bark than a feline's meow.

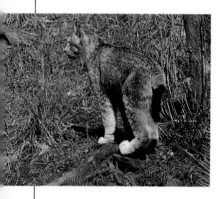

As with all cats, leaping is swift and instantaneous from practically any position. The felines' canine teeth are the sharpest and longest of all the flesh eating mammals while the jaw action is scissor-like: slicing up and down but not actually meeting. The top of the tongue is rasp-like and, in the larger cats, capable of extracting blood simply by licking. The retractable claws (only the cheetahs are fixed) keep the sharp hooks in excellent hunting condition.

Since hunting is mostly done at night, nature has compensated by sharpening the hearing and smelling senses. Cats' ears contain hairs which capture tiny air vibrations enabling the animal to pin point movements. Also, the whiskers are extremely sensitive and capable of sending action signals from the tip to the nerve roots.

Cats' eyes give off a green glare at night created by a reflecting layer called the tapetum on the back lining of the eye itself. This layer reflects light back onto the cones of the eye increasing the light they absorb and enabling cats to literally see in the dark.

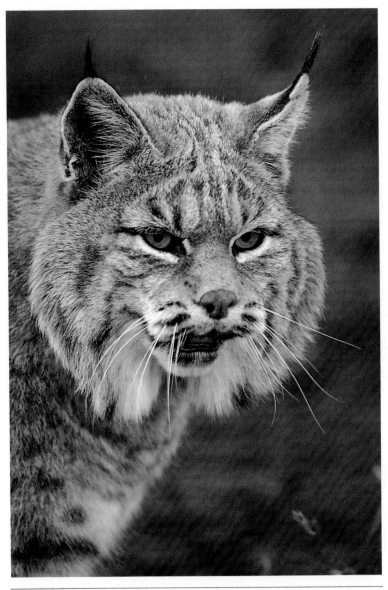

Above: The 200 - 500 mm zoom lens on automatic provided the opportunity to catch this striking pose.

Facing page: We took the photo of this beautiful cat from a temporary blind of dead trees and branches which we set up earlier.

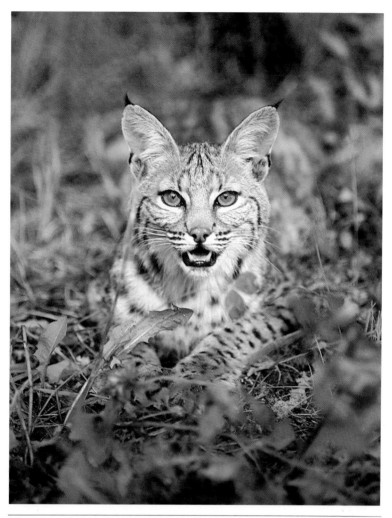

When feeding hungry kittens, females may be forced to hunt by day. We were in typical bobcat country but did certainly not expect to see one, let alone find a family. The mother kept a wary eye from a distance, occasionally coming close enough for a 200 mm shot.

BOBCAT *Lynx rufus*

This shy, solitary cat is rarely seen during daylight hours as it prefers the security of darkness. Car lights or campfires could pick up a reflection from the eyes, but take care: like all wild animals, a bobcat can be vicious if cornered.

It is the smallest member of our Canadian wild cats, measuring approximately 68 cm, with a 12 cm tail with a black patch on top. Two to four young, born in the spring after a gestation period of 30 days, usually leave their mother in the autumn to fend for themselves.

Broken rock outcroppings near willow meadows and marshes are favored habitat for dens, as an excellent supply of rabbits and mice is assured in such areas. Also included in the bobcat's high protein diet are birds, eggs, frogs, snakes and even porcupine.

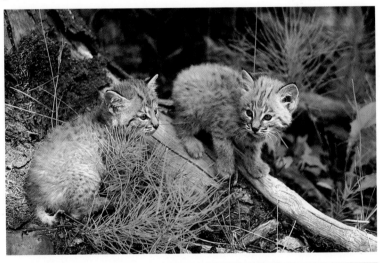

The kittens' curiosity overcame caution as they left the den, allowing us to photograph them with the normal lens. We had no tripod with us, so we hand-held the camera on automatic exposure to cope with the deep woods' dappled light.

HOARY MARMOT *Marmota caligata*

"Whistler," he is called: an apt name indeed, as his warning whistle can be heard long before you reach the colony. An intricate network of tunnels containing grass-lined burrows make up the marmot's underground settlement, which can cover an area the size of a football field and house twenty or more animals. The site is chosen amidst large boulders to discourage attacks from grizzlies and other predators.

This large rodent, with males weighing up to nine kilograms, spends most of its life at rest. The short alpine summers decree that a lot of eating and lying around must be done to fatten up for the long winter's sleep. Hibernation starts in September and does not end until May. Mating occurs every second year; two to five young are born five weeks after hibernation ends, and emerge from the burrow in July.

Marmots are very social animals and extremely interesting to watch. When travelling to and from their pasture, they greet each other by touching noses and, if in a playful mood, will wrestle and box. Combatants will tumble around or stand on rear legs and harmlessly push each other with their front paws.

Slow and quiet movements and a telephoto lens are the key ingredients to successful marmot photographs. After sighting a marmot at his lookout, approach very slowly. As you move within camera range, the animal will disappear underground. Make yourself as inconspicuous as possible and be prepared to wait. Eventually, the marmot will reappear to pose for you.

Likely places to find these fellows in Banff National Park are on the Helen Lake and Peyto Lake trails, and on the Plain of Six Glaciers teahouse trail near Lake Louise.

In Jasper National Park, look for them at Marmot Basin, on Mount Edith Cavell trail, or at the top of Whistler Mountain at the end of the gondola lift.

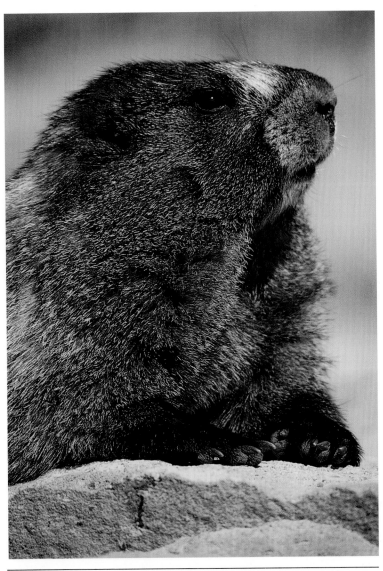

By setting up our tripod and 200 - 500 mm zoom lens in the centre of a marmot colony, we were able to photograph full body and portrait shots from one position. It was a bright, overcast day, producing no harsh shadows but still giving a sparkle to the eye. We were able to shoot in any direction as the light was identical no matter which way we pointed the camera.

COLUMBIAN GROUND SQUIRREL
Spermophilus columbianus

During the cooler months, members of a colony of Columbian ground squirrels hibernate for days at a time, using stored fat as nourishment. Body heat drops and breathing is slowed to approximately three times per minute. After each sleep, they slowly awaken, clean their nests (composed of dried grasses and weeds), eat a few stored seeds or nuts and perhaps have a walk outside before returning to the burrow to continue their sleep.

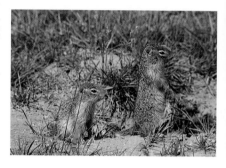

From April until August they are very active along the park highways, in most campgrounds and picnic sites. Burrows, located in open meadows and forest clearings, usually have a dirt mound at the entrance serving as a lookout point. At any sign of danger, the lone sentry will sound a shrill whistle sending other members of the colony scurrying to the security of their tunnels. If you remain quiet and very still, they will gradually return. Columbian ground squirrels are great fun to watch, especially the young.

Being omnivorous, the ground squirrel will eat almost anything. Most food is vegetation but they do rob nests and eat insects.

The Vermilion Lakes road in Banff National Park affords an excellent opportunity for photos of Columbian ground squirrels, as do many picnic areas and campsites.

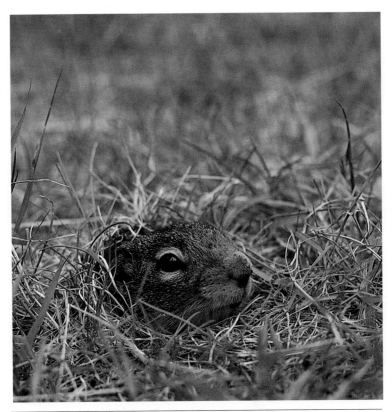

In areas where they are conditioned to people, it is reasonably simple to capture these animals on film as long as you are patient. With even a simple camera, satisfactory results can be achieved if you get in close and shoot from a low angle. At other times, the 80 - 200 mm zoom is useful as it allows portraits, full body shots and family groups to be taken from the same position and with just one lens.

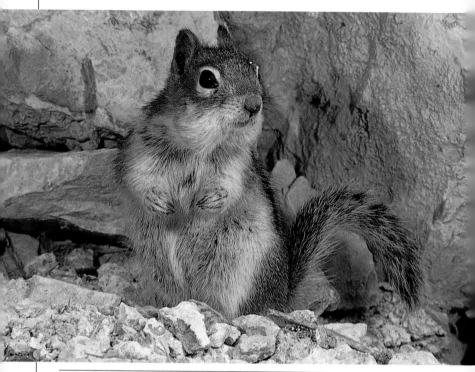

This appealing creature repeatedly posed at this same location. It was impossible to photograph with available light, as deep shade covered at least half of the area. We slipped a dedicated flash head onto the camera, and used the 90 mm lens.

GOLDEN-MANTLED
GROUND SQUIRREL *Spermophilus lateralis*

In the mountain parks, these entertaining little creatures are to be found almost everywhere. The beautifully marked animal is neither as communal nor as abundant as the columbian ground squirrel, but is often seen near campgrounds, picnic sites and along hiking trails from May through October.

Their burrows, as with those of other ground squirrels, have passages several metres long leading to a grass-lined bed chamber. Like many other hibernators, they will awaken several times during the long winter months for a stretch and a light snack.

The golden-mantled ground squirrel enjoys the security of rock slides and boulders as protection against predators. The young emerge in July to join the adults in play. Their food consists of seeds, fruit, insects, bird eggs and lichens. Some food is harvested and stored in the burrow for the short wake-up periods during hibernation.

YELLOW-PINE CHIPMUNK
Eutamias amoenus

These little creatures are often seen on the hiking trails or in the picnic areas of the parks. Should you hear a steady *chip, chip, chip*, it is probably a chipmunk, warning all wildlife of your presence. This call, accompanied by short jerking movements, may come from the tree tops or from any vantage point such as an old stump. The yellow-pine chipmunk is a very alert little animal and nothing seems to escape its attention.

Chipmunks are constantly busy, seeking out a varied diet of seeds, berries and insects. They will fill their cheek pouches to almost twice the normal head size, then transport the food to a secret hideaway, or to their underground nest chambers, for future use. Hibernation takes place from November to March.

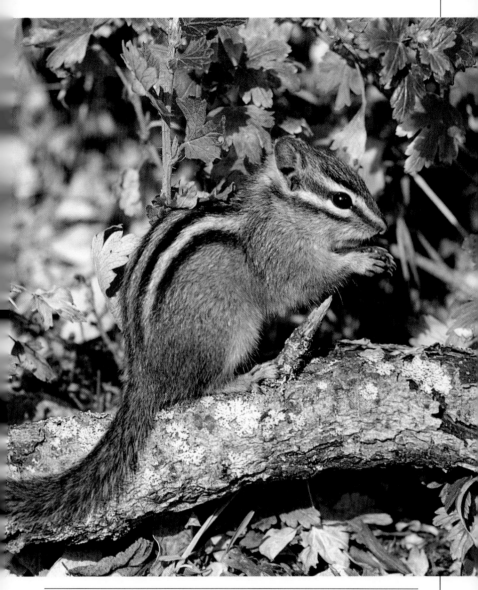

As this fellow returned repeatedly to the same feeding station to collect wild gooseberries in late September, we set up the tripod, 200 mm lens and two electronic flash heads to capture this full body shot.

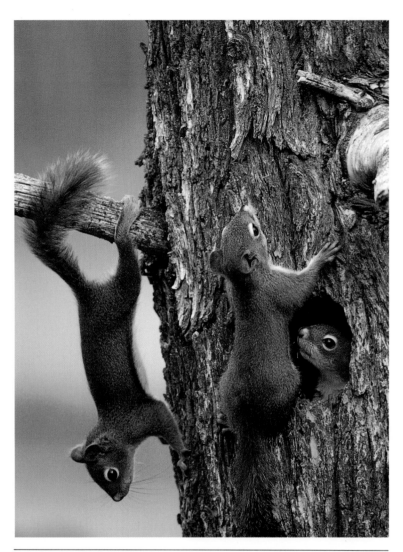

A vacated woodpecker hole, located six metres above the ground, supplied this squirrel family with a perfect nest cavity. By scaling a nearby cliff with tripod and 800 mm lens, we were able to get family shots at nest level. Exposure was measured by hand-held meter, incident reading, in rapidly fluctuating light conditions.

RED SQUIRREL *Tamiasciurus hudsonicus*

This noisy and energetic little tree-dweller will charm you as you hike the park trails. His chattering call, used to alert others of your presence, will attract you to his perch in the coniferous forest. While in the campgrounds, you may be rudely awakened (as we were) by seed cones being dropped on your tent, or tiny feet scampering on your vehicle.

The red squirrel keeps busy most of the day, gathering food, defending its territory and marking boundaries with its scent. A mid-day siesta on a branch restores energy for the afternoon's activities.

Any hollow tree, dense brushpile or hole in the ground serves as a nest chamber and a safe place for storing the winter's food supply of seed cones. Mushrooms are also picked in season and placed on branches to dry. During warm weather, the diet is varied to include insects, birds and their eggs, flowers, nuts and plant materials.

Some females breed twice a year, with the blind, furless young being born in late May and in late August. Soon after birth, they are racing and leaping through the forest canopy. At about ten weeks, the young squirrels leave the nest to establish territories of their own.

Even though they possess great speed and agility, there are others even quicker. The red squirrel must constantly be on the alert for hungry hawks, martens and fishers.

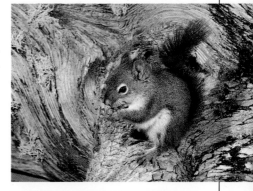

Using a selected tree stump to which we had glued lichen as naturally as possible, we gathered cones and placed them at the base. A reading was taken with a flash meter, and we used a dedicated flash.

BEAVER *Castor canadensis*

Beavers are famous for controlling lakes and rivers to meet their needs. If a suitable pond or lake is not available, these industrious animals will create one by damming a stream. Trees are cut and dragged into place and gaps are filled with mud and stones to make the damming structure watertight.

When the water level has risen satisfactorily, a lodge is constructed, with living quarters above waterline and two underwater exit or escape passages through the floor. Not all beavers build lodges; some simply dig homes into the banks of rivers or lakes.

A lodge is usually occupied by an adult pair, their kits and yearlings. As many as twelve beavers have been found in a single structure. The permanency of lodges and dams depends largely on the availability of willow and aspen, which form the staples of the beaver's diet.

When aspen leaves turn gold, the beaver starts harvesting tree bark for the winter's food supply. Locating a choice tree, the animal will usually sit on his tail and proceed to fell it with the four self-sharpened teeth which continue to grow throughout the animal's lifetime. Once down, the tree's branches are stripped, cut and dragged by mouth along beaver-built canals to the lodge, where they are firmly anchored in mud.

As the lake freezes over, the adult beaver fills its lungs with air, finds deep water some distance from the lodge, expels the air to form a large bubble between water and ice and creates an emergency oxygen supply.

One late September afternoon we stumbled across beavers hurriedly building a new lodge. After spending several days quietly watching them, we were able to learn their habits and to gain their trust. The next few days were spent photographing these energetic animals as they chewed, felled and dragged trees off to the construction site. One big fellow became so unafraid he allowed Esther to stroke his fur.

The end of September and early October are the best times to look for beavers as they will often venture forth during daylight hours. A walk or drive along the Vermilion Lakes near Banff Townsite takes you into beaver country. In Jasper Park, Edna and Talbot lakes are quite active, as are the waterways along the north side of Highway 16 just a few kilometres west of Jasper Townsite. Take a meter reading for your exposure when photographing beavers, as the animals' dark coats and the water may throw off your automatic setting.

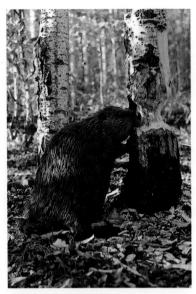

After five days, we were permitted near enough to photograph these beavers at Talbot Lake with the normal (50 mm) lens. Frustrated with the ever-changing light conditions, we put the camera on automatic, switched the motor drive to continuous action, and shot the entire roll: a move we regretted when the film ran out just before the tree was felled.

The beaver uses the single split claw on each of the rear feet to groom its fine fur, and adds a little oil from a gland at the base of its tail to waterproof its coat.

Overleaf: This photo shows the typical dam, lodge and canals built by one energetic beaver family. The dam is constructed to regulate water levels for safety at the lodge, to preserve and store winter rations, and to create canals deep enough for transporting branches and logs from the surrounding woods. We used automatic exposure for this scenic.

Inset: To capture the action at close range, we positioned ourselves on the dam itself and used a 35 mm (wide angle) lens.

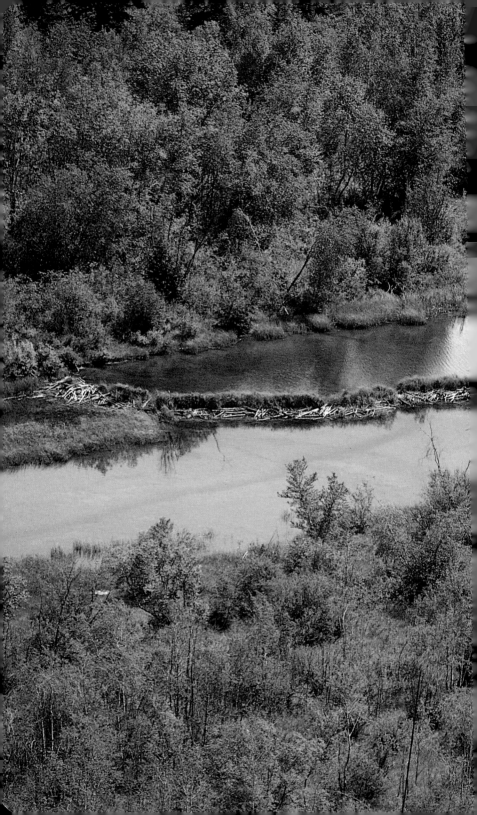

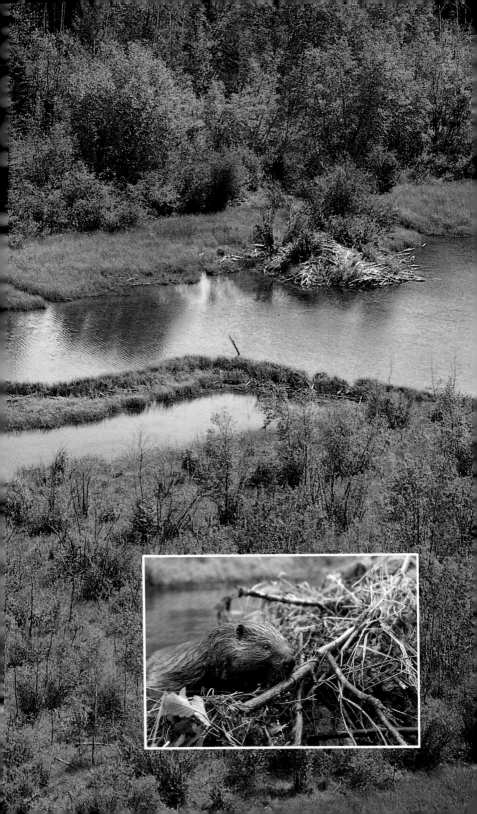

DEER MOUSE *Peromyscus maniculatus*

The deer mouse is found wherever suitable food and shelter is available, which means that it is extremely common throughout North America. Various seeds and nuts are favoured, but the deer mouse will also eat insects, spiders and fruits.

The nest is a round, soft ball of fine grasses located in any dry cavity beneath rocks, below ground or perhaps hidden in a hollow tree. Any place affording shelter will do. One of the most prolific mammals on earth, female deer mice will first breed at the age of five to six weeks, and a mature pair can produce an average of three litters a year and raise three to five baby mice each litter. Deer mice are preyed upon by all the carnivores, as well as by birds of prey.

When darkness falls, watch for the reflected light of your campfire on tiny eyes. Picnic tables, equipment and even the windshield of your car may display the deer mouse's perfect little tracks.

Facing page: A keen eye and an understanding of nature are important assets in locating the specialized homes of deer mice. Here, they had dug rotten wood from under the bark of a dead tree and made safe tunnels to their nest chamber. We set up the equipment using tripod, two electronic flash heads and a 50 mm lens. The equipment was accepted immediately, but a human at close range was not. By adding a long remote control cord we were able to work successfully from a distance.

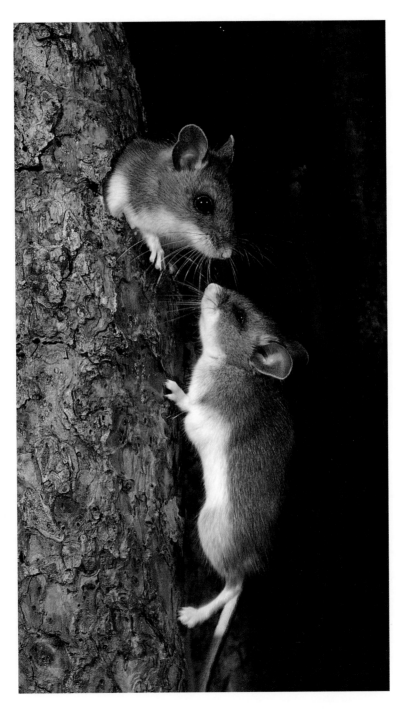

MUSKRAT *Ondatra zibethicus*

The name muskrat is derived from the animal's habit of depositing a secretion from the musk glands to both mark home base and attract a mate. It is not a rat, but is more like a giant mouse or vole. An average muskrat is 64 times heavier than a deer mouse: its head and body length is 35 cm and its tail measures 30 cm. This "mouse" is a prolific breeder and is sexually mature in approximately six weeks. Two or three times a year, an average of four young are born, blind and without fur, each weighing less than 20 g.

Marsh and lake waters must be deep enough not to freeze solid and must provide lots of aquatic vegetation in order for this animal to survive. It will either build a den dug into the bank or construct a house in the water of anchored vegetation. Glossy fine fur traps air and prevents cold water from reaching the skin. The muskrat is an excellent swimmer, using semi-webbed feet and a sideways motion of its tail.

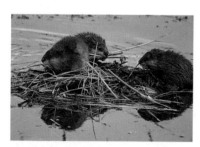

Vermilion Lakes near Banff Townsite and Talbot Lake east of Jasper Townsite are accessible muskrat habitat. Hip waders, patience and a long lens are all advantageous when photographing them.

Sudden rains flood the marshes, forcing the muskrats to seek higher ground. In this instance, they chose a partially submerged dwelling and proceeded to build it higher. Using the 800 mm lens, we caught some interesting images. When using a telephoto lens, it is wise to keep your hands off the camera during exposures, and to wait a few seconds before tripping the shutter a second time, to avoid losing clarity from vibration.

Muskrats build their shelters each year on the marshlands and shallow lakes before the onslaught of winter. A telephoto lens (200 mm in this case) compresses space, and gives the impression that the lodges are closer together than they are. The photo was taken at Vermilion Lake.

PORCUPINE *Erethizon dorsatum*

They appear timid and slow but they are excellent climbers, spending many hours in the trees eating leaves, bark and tender shoots. Antlers and bones are chewed to provide a mineral supplement.

A hardy, solitary, mostly nocturnal animal, a porcupine is at home wherever he happens to be: in a natural cave, a hollow log or in a brush pile. Porcupines will spend several days in a tree when soft, deep snow makes travel difficult.

This animal's only means of defence is his formidable coat of loosely anchored quills, the tips of which are covered with multitudes of minute barbs which make removal very difficult. A switch of his tail will usually deter most predators. The belly, face and throat are without quills and vulnerable, a fact which the bobcat, the fisher and the wolverine have learned to use to advantage.

In April or May, after a gestation period of seven months, a lone, fully furred, 500 g baby is born. The soft quills quickly harden and the young animal is capable of feeding itself and following the female within a very few hours.

Only one other North American rodent, the beaver, is larger than the porcupine, which weighs approximately ten kilograms. The porcupine has a lifelong craving for salt and will chew anything that has been subjected to perspiration or road salt, including axe handles, canoe paddles, outhouses, shoes and car tires.

The porcupine is found throughout our mountain parks. Watch the roadsides at dusk.

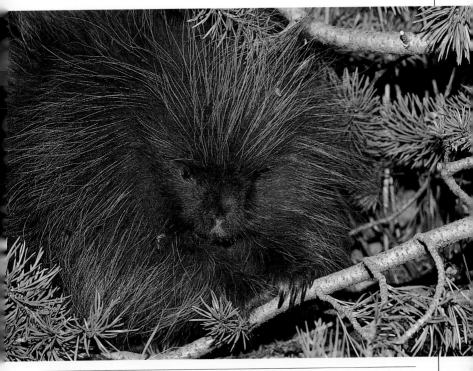

One early morning in Mosquito Creek campground we came across this porcupine up a tree, taking refuge from some overly exuberant children. Being opportunists, we quickly mounted a 90 mm lens and set up the dedicated flash for some splendid shots.

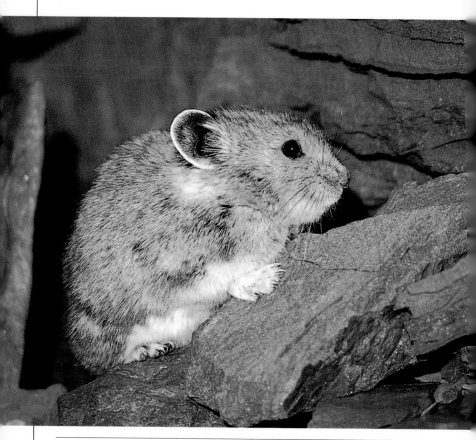

Due to the multitudes of nooks and crannies in their rock slide
territories, photographing pika can be very frustrating.
Patience and careful searching will reveal a favoured spot to
which the pika will return again and again. We used our
200 - 500 mm zoom lens for this photo.

PIKA *Ochotona princeps*

"Cony" and "rock rabbit" are other names by which these appealing 15 cm, 140 g mammals are known. They have a round body, short ears and legs, no tail, a thick fur coat and fur on the soles of their feet: all features which help to conserve heat. The little pika does not hibernate, but remains active all winter, even when a heavy blanket of snow covers his territory.

The pika makes a home in rock slides. Should it move to a slide with rocks of a different colour, its own colouration will very gradually change for camouflage — from browns to greys, or vice versa. A nasal *peek* announces its presence, and a pile of droppings on a rock whitewashed with urine will give a further clue, as pikas habitually defecate on the same rock.

Summer months are occupied in gathering plants, grass and shrubs, cutting and spreading them in the hot sun to dry, then storing the harvest under a large boulder sheltered from the coming snow. In its rock-strewn world, the pika has few enemies. Eagles and hawks may get a few of these animals, but only the weasel is slender enough to manoeuvre through the tunnels in pursuit.

Pikas may breed twice a year, producing 2 to 5 young in May and July.

Pika habitats include most alpine trails such as those near Peyto Lake, Lake Louise and Mount Edith Cavell. Another good pika photography location is the large rock slide approximately three kilometres north of Jonas Creek campground in Jasper National Park.

SNOWSHOE (VARYING) HARE
Lepus americanus

Its oversized back feet, for better traction in deep snow, give the snowshoe hare its name. Unlike the rabbits, who remain the same color all year, hares' coats vary with the seasons: brown in summer, white in winter. Baby rabbits are born naked and blind whereas those of the hares arrive fully furred, eyes open, ready to tackle the world. No den is built; a saucer-shaped depression under shrubs or brush is home.

Shortly after giving birth to an average of three precocious leverets, the female may breed again, repeating the process up to four times throughout the warmer months. The young mature in six weeks to start their own families. Due to this high production rate, the hares literally eat themselves out of house and home approximately every ten years. The snowshoe's winter food supply is then gone as shrubs, bark and branches have been nibbled beyond reach. Starvation and disease set in, reducing the population drastically. As the vegetation returns, so do the hares.

Most carnivores feed upon the 1 to 2 kg hare, but the lynx is so dependent on it as a food source that the population cycles of the two species are closely keyed to one another.

This largely nocturnal animal is found in valley bottoms and near streams where shrubs and willows grow. The snowshoe hare is very common throughout the mountain parks.

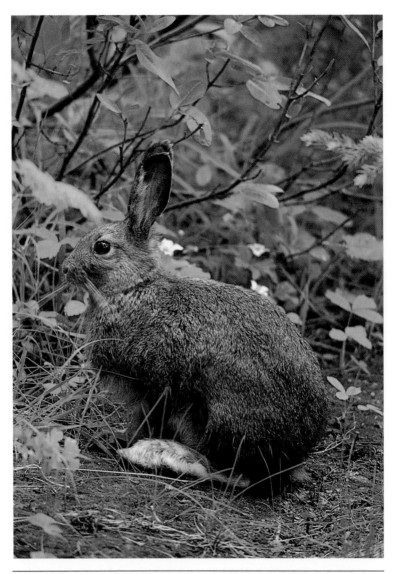

During a rainy June weekend at Johnston Canyon camp-
ground in Banff National Park, we spotted this hare. Mounting
our cameras with the 200-500 mm lenses, we managed to get
a number of good exposures, despite readings of between
1/8 and 1/4 second. In situations like this a sturdy tripod is
essential.

WAPITI (ELK) *Cervus elaphus*

This second largest member of the deer family was named "wapiti" by the Shawnee Indians and, increasingly, by naturalists. As they browse continually on shrubs and young trees, they assist nature in keeping the meadows open and in halting advancing forest growth.

Although females weigh approximately 225 kg, mature (over 3 years) bulls can tip the scales at 450 kg. This could include a magnificent pair of antlers weighing up to 22 kg. Antlers are dropped during the winter, and start again in "velvet" each spring. They grow rapidly until early fall when they are polished, ready for the rutting season. The rut begins in mid-September as the bulls start gathering a harem which could consist of several dozen cows.

Wapiti are by far the most vocal of the deer family. Few wilderness sounds of autumn can compare to the beautiful, bugle-like call ringing through the valleys as the females are rounded up. The rut demands a tremendous amount of energy on the part of the bull; not only must he collect the cows but must also hold them against rival bulls who would enlarge their own harems. At this time many sparring matches occur. Spotted calves (often twins) are born late in May.

Wapiti are found in numerous locations throughout our mountain parks. They appear to be more numerous than deer but this is only because they are larger and easier to see, they have less camouflage and they tend to stay in groups. Best times for sightings are normally early morning before the sun is high and one half-hour before sunset until dark. During the rut, caution is thrown to the wind and sightings may occur at any time.

Photography is at its best during the rutting season, mid-September to early October. The bulls are in their prime with fine coats, heavy necks and freshly polished antlers, and the air is filled with the unforgettable sounds of bugling calls and rattling antlers. In the open, we prefer to use our 200 - 500 mm zoom lenses. When following an animal in the woods, our choice is the 200 mm f 2.8 lens to cope with the poor light conditions and the multitude of trees.

We have found the best place to photograph wapiti during the rut in Jasper National Park is at Whistler Campground. Located close to Jasper townsite, the campground and surrounding area appear to be the centre for a resident herd.

In Banff townsite, cross the bridge on Banff Avenue, turn right on Cave Avenue, follow Cave about one kilometre to Birch,

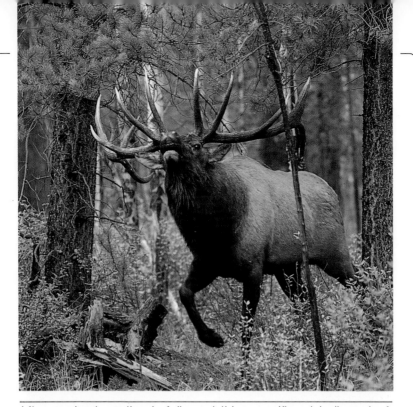

After we had cautiously followed this magnificent bull most of the day through the forested area near Whistler campground, he suddenly became aggressive. Another bull was trying to make off with one of his harem. Unknowingly, we had gotten directly between the two, and we slipped behind the nearest tree for shelter. Fortunately, the bulls were more interested in each other than in us and we were able to capture several shots showing the tremendous power of this stately animal. With camera on tripod, as the light was low, we set the lens at f 2.8 to achieve as much speed as possible. We used automatic to avoid having to change shutter speed whenever the light shifted, and the motor drive was positioned on "continuous" for fast action.

and turn right to the ballpark, a favourite wapiti spot. Another Banff townsite location is found by going east from downtown on Banff Avenue 2.5 km, and turning left to the trailer parking lot. The meadow along the railway is productive at times.

Also in Banff National Park, the meadows at Silver City point of interest on Highway 1A near Castle Mountain often contain wapiti.

In Yoho National Park look for wapiti near the town of Field. In Kootenay, they can be found throughout the valleys, as they can in open meadows in Waterton Lakes National Park.

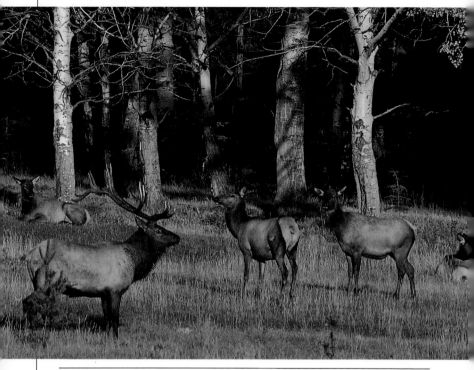

As morning sun popped over the treetops near Wabasso Trail head, Jasper, it created an ideal setting for this herd bull and his harem. By using the 200 - 500 mm zoom on tripod and taking an incident meter reading we were able to capture the mood.

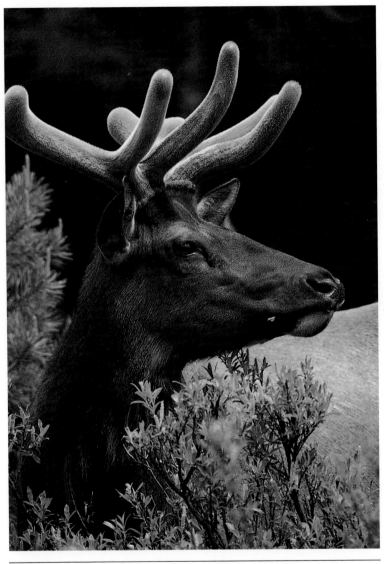

A late spring shot near Poboktan Ranger Station, Jasper National Park. The dark background and evening light made it necessary to use our Minolta hand-held meter on incident mode, to capture the rim lighting on the antlers. Had we used a reflected reading or automatic, the highlights would have been grossly over-exposed and the detail would have been lost.

MULE DEER *Odocoileus hemionus*

Although seldom heard, mule deer do have voices: fawns bleat, and males will utter a low grunt during rut. The most familiar sound, however, is a snort. When alarmed, mule deer exhale air through their nostrils, creating a loud snort, and stamp the front feet. They will also "pronk": jump straight up and down striking the ground hard with all four feet simultaneously.

These browsers feed chiefly on twigs, shrubs and some grass. They are most likely found along the edge of coniferous forests, willow-fringed streams and forest clearings. Mule deer are easily identified by the very large ears and small black-marked tails. The mule deer and the white-tailed deer are the only members of the deer family to change body color with the seasons: from reddish brown in summer to grey in winter.

The mule deer's autumn rut is certainly not as dramatic as the elk's, but it is an excellent time for sightings as the bucks become aggressive in their quest to maintain two or three females. It is not uncommon to witness a buck in the open, sniffing tracks and branches or urine spottings to determine if the scent indicates a receptive doe nearby. At this time he is in his prime condition: his coat heavy, his antlers full and polished, and he is proud.

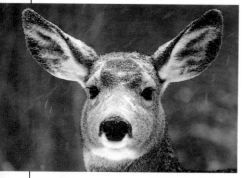

We found this cooperative doe on a mid-morning drive up Mount Norquay. Our camera, with 200 - 500 mm zoom lens, was mounted on the window pod. It was necessary to take an incident light meter reading, due to the snow and the deer's position shifts from light to dark backgrounds.

Fawns are born in June and are mobile within minutes. During the first week or so, the doe hides her scentless fawn in the grasses or forest for long periods of time. She will return regularly for feedings, groomings and to consume the fawn's body wastes. If the young deer becomes impatient and wanders, a gland between the toes will leave a scent trail for the doe to follow. Should you find a fawn apparently "lost" or "abandoned," do not touch it as the mother is not far away and will return when all danger has passed.

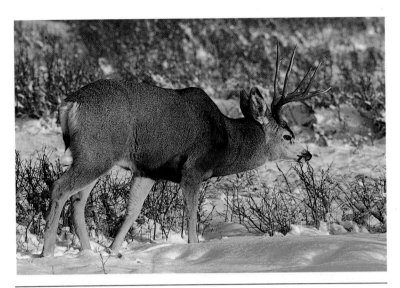

Early morning sunlight accents this buck as he daintily nibbles the tips of saskatoon bushes in Waterton Lakes National Park. Tripod and cable release were essential here as the freezing temperatures had reached through our heavy clothing, making it difficult to hold the camera still enough to ensure no camera shake. It is well to note that in freezing temperatures, the camera should be kept cold. Allowing the camera to alternate between warm and cold can create a build up of condensation, which could freeze and lock the mechanism. We used incident reading here.

As common as these animals are, their habitat, color and size make them difficult to locate. A good bet for sightings in Banff National Park is along Highway 1A or up Mount Norquay drive, during early morning or late evening. In Jasper, keep a sharp lookout east of Jasper townsite from Snaring River turnoff, along Highway 16 to Rocky River. These deer are frequently spotted in the townsite itself. A slow drive or a walk through the streets or outskirts may reward you. Look for them also throughout Waterton Lakes National Park, especially in Waterton townsite and in the Blakiston Valley.

After quietly following a buck for almost three hours one late September afternoon, he finally accepted us and began munching on rose hips, coloured leaves and mushrooms. As in hundreds of other situations, patience again paid off. One must become part of the environment in order to successfully photograph wildlife.

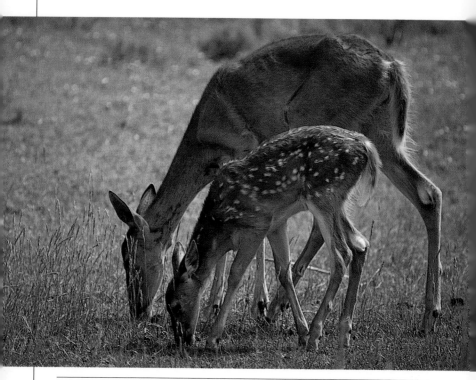

Rarely is one afforded the opportunity to photograph a white-tailed doe with her fawn, as they are extremely shy. We were fortunate that our 400 mm lens was already mounted on a camera. We hastily grabbed the beanbag and, using the window frame as a stabilizer, made a couple of guess exposures. Through experience, one learns to judge the value of light to within 1/2 stop.

WHITE-TAILED DEER *Odocoileus virginianus*

White-tailed deer closely resemble mule deer in their seasonal colourations, but the points of the white-tail's antlers branch off a main beam, while those of the mule deer are forked. These animals are not as stocky as mule deer, have smaller ears and a larger white tail. When danger threatens, the tail is raised and wagged from side to side, a "flag" signal that is unmistakable and beautiful to watch.

This is not an easy animal to locate; the habitat is much the same as that of the mule deer, but white-tail are very shy and tend to keep closer to the forest. Like the mule deer, they occasionally "snort," but they prefer to run than to stomp around making noises.

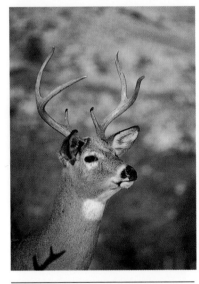

The most opportune times for sightings along the highway clearings are just before sunrise and after sunset, for it is then that the white-tail cautiously leaves the shelter of the forest in search of tender grasses. Highway 1A from Banff to Lake Louise is often rewarding, as is the Talbot Lake area east of Jasper townsite. In Waterton, look in the meadow near the riding stable.

Try photographing from the window of your vehicle as these timid animals are not about to remain in a clearing for long. The light is low when the deer is most likely to come out of the trees, so use your largest aperture to give the speed necessary to capture action.

Note the branches off the main stem on the white-tailed deer's antlers. The shadow on its chest from another buck shows how these deer will accept the company of other males after the rut is finished. A portrait often shows the alertness of an animal more powerfully than does a full body shot. Incident meter reading was used here, with a 400 mm lens.

MOOSE *Alces alces*

The moose is the largest deer in the world and the only one to enjoy an aquatic lifestyle. The bulls in the mountain parks can weigh up to 550 kg and require 20 to 25 kg of feed daily. Long legs and big feet are a tremendous asset when seeking favourite morsels such as waterlily tubers and other aquatic plants. In deep water, the long hooked nose will rise periodically to the surface, almost like a snorkel. For a change of diet, moose will browse on leaves, tender tree shoots and grasses. When winter ice has sealed the ponds and lakes and snow has deeply covered the grass, twigs and evergreen branches fill their bellies until spring.

Male members of the deer family produce a new set of antlers each year. "Velvet" knobs appear in early spring, reaching full size at a rapid rate. This "velvet" is a soft skin-covering filled with blood vessels, which nourish the bone structure. By September, the antler has fully developed and the skin has dried. Now the antlers are prepared for the rut by being cleaned and polished on trees and shrubs.

Only the largest and fittest bulls are successful in mating season. Smaller males try, but are usually discouraged by either intimidation or brute force. Well after the rut, in mid-winter, the antlers fall off as they have served their purpose. It is then difficult to distinguish the bulls from the cows.

Two-year-old females give birth to calves in May, and breed every year thereafter. Within hours the young are ready to travel. A protective female moose can be quite dangerous.

As with most ungulates, the best times for sightings and photography are from sunrise until mid-morning. The moose is shy of sunshine and will retreat into shady wooded areas except during cold weather, when one can see moose in full sunshine at midday.

The most opportune time of year to find moose is during the rut when the bulls are continually wandering, grunting their way through the woods in search of cows in heat. We have had a measure of success by following a bull, staying back far enough not to alarm the animal but, at the same time, getting

Facing page: With a 200 mm f 2.8 lens mounted on a tripod (as the light was poor) we trailed this bull in Sunwapta Pass for better than two hours one September morning. Finally, he accepted our presence, found a clearing and proceeded to feed. An incident meter reading exposed the antlers correctly.

him used to our presence. He will be more at ease if you wear multi-coloured clothing which tends to soften the human image. Hours and kilometres later, he will eventually find a mate or a favourite feeding spot. Now you must move cautiously for you don't want to startle him or be forced to ride his antlers. Taking only a step or two at a time, patiently moving only when he is looking the other way, you may get close enough with a 200 mm lens to raise goosebumps and set your adrenaline going. Stay close to a large tree or other solid obstacle in case the moose becomes aggressive.

In Banff National Park, look for them at Moose Meadows on Highway 1A near Banff townsite, on Waterfowl Lake roadway and in the Bow Pass.

Saskatchewan Crossing north to Sunwapta Pass is another likely area for sighting moose.

In Jasper National Park, look for them through the Sunwapta Pass area, on Beauty Creek through to Bubbling Springs, along Highway 93A from Athabasca Falls to the junction of Highway 93 and along the Snaring River road east of Jasper townsite.

In Waterton, moose can often be seen in Blakiston Valley. In Yoho, check the salt lick one kilometre south of the natural bridge.

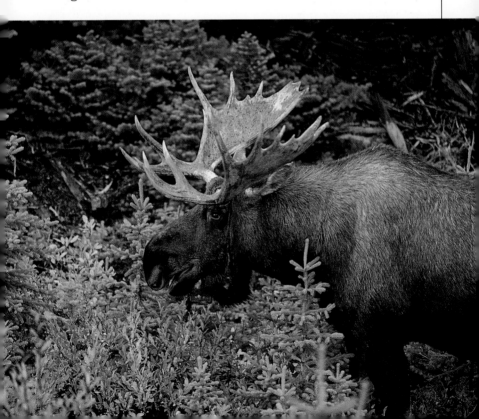

WOODLAND CARIBOU *Rangifer tarandus*

Caribou are the only members of the deer family in which both sexes grow antlers. The males follow the pattern of other deer by starting "velvet" growth in the spring and dropping the antlers during winter; the females start theirs in the late summer and drop them the following spring. This may provide a means of defense for females carrying young, which are born in late May.

Woodland caribou live in small groups or singly, in the protection of heavily treed areas, unlike tundra caribou which create their own "forests" by travelling in large numbers. The woodland caribou do not migrate or range as far as their northern cousins do but, as the seasons change, they move from high elevations to low and back again in a continuous search for food. Leaves, lichens, dandelion blooms and the early spring growth of horsetail make up their main diet.

Nature has provided these animals with oversized feet, equipped with a pair of large dew claws at the heel. The feet spread to form "snowshoes" for winter travel, provide better footing in swamp areas and act as paddles for swimming. The dew claws give a peculiar clicking sound as they strike the hoof whenever the animal moves.

The caribou's beautiful, heavy hide is constructed of a very fine underfur covered with an outer coat of hollow guard hairs,

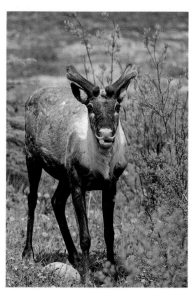

which gives buoyancy in the water as well as insulation from the cold.

Due to its limited population, the woodland caribou is not a common sight, but with a bit of luck, you may come across a few during spring or autumn migration. The extreme north end of Banff National Park is a likely area in which to see them. In Jasper National Park, the meadow across the river at Beauty Creek, the Jonas Creek area and the bald hills northwest of Maligne Lake are all possibilities. If you are patient, you will marvel at how docile and approachable these constantly moving animals can be.

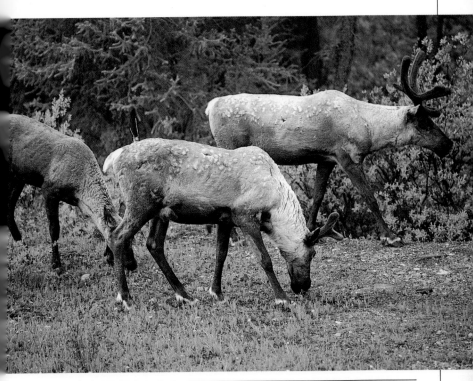

Above: Two bulls and a cow feeding at the roadside were photographed from our camper window, using the telephoto 200 mm zoom lens with the bean bag for support.

Facing page: In early June and late autumn, caribou follow an age-old migration route thorough the Jonas Creek area of Jasper National Park. This young bull was greedily filling up on dandelion blooms before moving on. The 200 mm zoom lens, with camera on automatic exposure, was used to accommodate rapidly changing light conditions.

BISON *Bison bison*

It is estimated that no fewer than 60 million bison, Canada's largest native land mammal, roamed the Central Plains of North America little more than a century ago. Native Indians used every part of the bison for food, clothing, shelter and tools until white men brought rifles into the country, causing the destruction of hundreds of thousands of animals. In less than 20 years the bison was almost extinct. Fortunately, this killing was stopped around the turn of the century and today approximately 50,000 animals of this species live in protected areas such as Banff and Waterton Lakes national parks.

To reach the Banff enclosure, leave Banff townsite along Banff Avenue and drive to the Hwy. 1 interchange. Turn west into the bison enclosure at the signs, paying particular attention to the treed areas, as buffalo enjoy the cool of the shade. In Waterton Lakes National Park, a drive-through paddock is one kilometre north of the park gate.

The massive bulls stand approximately two metres at the shoulder hump and weigh in the vicinity of 800 kilograms; females are about half this weight. Both sexes have the distinctive crescent-shaped horns.

Bison family photos can be interesting but obey the signs and remain in your vehicle, as the bison is fast and furious when aroused. If the great beast is close enough to fill your frame, or when taking a head shot with your telephoto lens, remember to open up your aperture to compensate for the dark image.

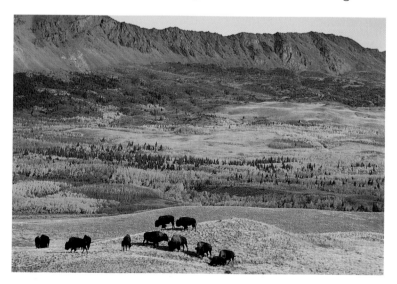

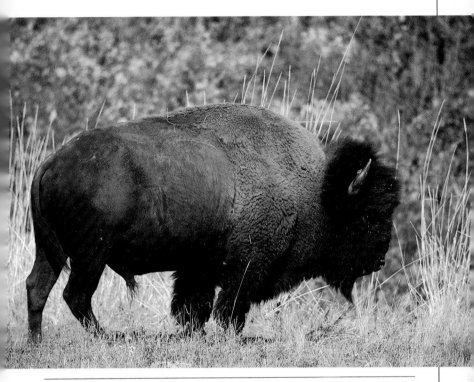

Above: In the autumn, the bull is magnificent. His strong body is healthy, his new coat is heavy and he has developed a very thick layer of fat to withstand the coming winter. A 400 mm lens mounted on a window pod was used to take this photograph. We used incident meter reading — opening up 1/2 stop to compensate for the dark coat. The bison is quite large in the frame yet thin clouds diminished the depth of shadow, otherwise it would have been necessary to increase the light reaching the film even more.

Facing page: In the large paddock in Waterton Lakes National Park, it is possible to achieve a photograph of these majestic animals reminiscent of the times when they roamed freely over the prairie hills. Remain in your vehicle and shoot through the open window, as these powerful animals are surprisingly agile and can cover a great distance in a very short time. We chose the 135 mm lens to take advantage of the surroundings.

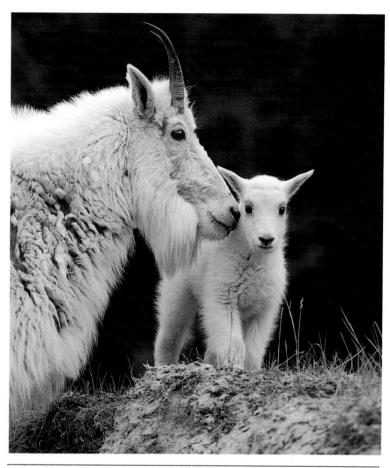

In June, mountain goats abandon the high country in search of essential minerals found only in the rich mud at specific licks. This photograph was taken at one such mineral lick, located south of the Athabasca Falls on Hwy 93. The high contrast between the white goats and the dark background made exposure difficult. Taking an incident meter reading to evaluate the light falling on the subject resulted in correct high contrast exposure.

MOUNTAIN GOAT *Oreamnos americanus*

The mountain goat, indigenous to North America, is not a true goat but is rather closely related to a group of Eurasian mountain antelopes. This cream-colored beast is splendidly designed for the rugged, high crags of the Rockies. Its short legs are ideally suited for climbing; large cushioned, flexible non-skid feet hold against slippery rocks; a thin frame affords safe passage along narrow ledges; and the thick, fine wool coat is excellent insulation against the bitter cold.

Mountain goats have few natural enemies. The eagle is one, occasionally a cougar will venture into their realm, and we have witnessed a black bear in vain pursuit of a goat dinner. Probably their worst enemy is the avalanche which sweeps down the mountain slopes, taking everything with it.

Their dagger-like black horns are their only defense. Occasionally a serious sparring match will develop between two billies as they fight nose-to-tail; digging each other in the rump and hind quarters where the skin is particularly thick. This seems to be a good way of working out frustrations without causing much damage: a hard head-to-head battle could be fatal. Most encounters between mountain goats, however, are only threats that are heeded without contact.

Nannies breed annually, with one or two kids being born in May.

In Banff National Park, as you drive Hwy 93 from Saskatchewan Crossing north to Coleman Creek, watch the mountain face on the east side of the road. Mount Wilson and Mount Coleman are goat habitats.

A short hike up Parker Ridge on the Sunwapta Pass takes you to the crest. There is mountain goat habitat on the west side.

In Jasper National Park, goats frequent Mount Wilcox and the overlook south of Tangle Creek. Look along the west side of the road on the Icefield Parkway, north of Athabasca Falls, for the animal lick overlook where goats are often seen, especially in June. A black mineral lick also popular in June is on Hwy 16 approximately 35 km east of Jasper townsite, between Syncline Ridge and Pocohontas.

In Yoho National Park, watch for mountain goats along the road to Takakkaw Falls. In Kootenay Park, the roadside lick at Mount Wardle is a popular location.

Should you be inclined to venture into their domain, use sturdy hiking boots. Some hiking experience is also important as the slopes can be extremely dangerous. Where possible, try to get above the goats for photographs, as you will find that angle more acceptable to the animals.

BIGHORN SHEEP *Ovis canadensis*

These denizens of high mountain meadows enjoy a peaceful lifestyle most of the time. After grazing on grasses they will lie about for hours, chewing their cuds and gazing into the distance with contented, dreamy looks. Occasionally, this relaxed life is threatened by a grizzly bear, a cougar or a wolf, but these predators are rarely successful, as the bighorn is as agile as the mountain goat on high, rocky terrain.

After the lambs are born in June, the family splits. The ewes and lambs form herds of a dozen or more under the watchful eyes of a matriarch. The rams form groups of up to ten individuals and go their separate ways, not seeing the ewes again until autumn's rut.

A ram's life is not as serene as a ewe's. In the male hierarchy, the leader is constantly being challenged by lesser members. One good butt to the head usually convinces the challenger.

Lesser members of the herd show respect for their leader by frequently rubbing, licking and grooming him. It is during the rut in November and December that the dominant ram has the extra burden of retaining his position; many capable opponents will challenge his right to breed the females. Sounds of butting horns can be heard for over a kilometre.

Excellent viewing areas in Banff National Park include: Highway 1A across the road from Back Swamp viewpoint (a bit of hiking is involved); Mount Norquay; Lake Minnewanka along the Stewart Canyon trail; the south slope of Mount Wilson near Saskatchewan Crossing.

In Jasper National Park try the Wilcox Pass trail and Mount Wilcox and Tangle Falls along the Icefields Parkway. A location approximately 8 km east of Jasper townsite — look across the bridge to the ridges on the right — is often productive, as is the Cinquefoil Ridge another 6 km farther on. Keep going east, cross the Rocky River to the second bridge. The ridge on your right, Syncline Ridge, is sheep habitat: a hike here could be rewarding.

In Waterton Lakes National Park, look in and around the townsite, and check out Red Rock Canyon.

Bighorn sheep are surprisingly easy to photograph as they are quite docile, but they are wild animals and must not be fed or harassed. Their tempers can change swiftly.

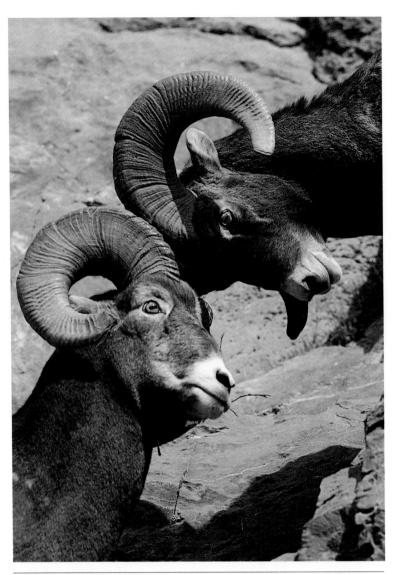

Rams continually assert dominance in hopes of eventually reaching the top of the hierarchy ladder and becoming "king" of the herd. In the fall, Syncline Ridge (Disaster Point), east of Jasper townsite, affords excellent possibilities for capturing this behaviour on film. As the light was good, we did not burden ourselves with a tripod while using the 200 mm f 2.8 lens. A direct average meter reading was used as all the tones of the animals and their surroundings were similar.

BIRDS

COMMON LOON *Gavia immer*

Loons are large birds, measuring up to one metre with a wingspan of 1.5 m. Most of their lives are spent on the water; they come ashore only to breed, nest, or occasionally to sleep. Because their legs are short and set far back on the body, loons have trouble manoeuvering on land and do not have the ability to stand upright.

The loon is able to dive to a depth of 60 metres or more and to remain underwater for periods of up to one full minute. Catching fish, their staple food, is no problem for these splendid birds.

Small lakes afford enough room for only one nesting pair, which will defend its territory vigourously. The same pair often uses the nest site over and over again, for as long as the two remain together. Two eggs are laid, but too frequently only one hatches. Loon chicks take to water immediately after hatching, at times snuggling under the female's feathers for safety and warmth.

Ideal loon habitat is a lake containing numerous small islands for nesting. Talbot Lake east of Jasper townsite is such a place.

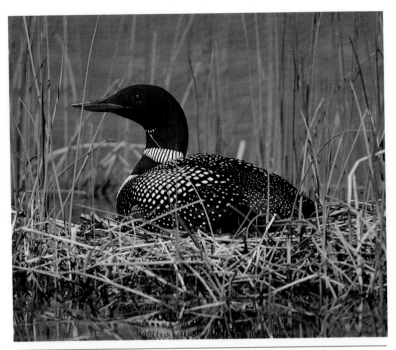

Our blind, in this case, was an empty cardboard refrigerator shipping crate which was originally set up about 90 metres from the loon's nest. Each day for a week we would return and move the crate closer until we were able to use our 300 mm lens. Taking turns, we entered the blind when the adult loons were off feeding so as not to disturb them, and waited in knee-deep water for their return. Rains had shrunk the cardboard, making it impossible to straighten up, and standing in water was not comfortable. But the thrill of photographing a loon on its nest without alarming it was a memorable and precious experience.

A smattering of thin cloud necessitated a repeated change of exposure, so we settled for the automatic setting on our cameras. The tripod and cable release were used.

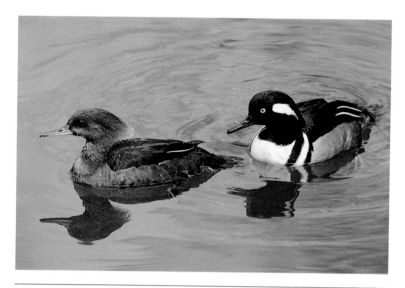

Our "Duckman" blind and the 200 - 500 mm zoom lens,
mounted on a tripod with a cable release, was used here.
The setting was automatic as the water was calm and of
good colouration. As it was mating time, the ducks were
pairing off and were less cautious than usual: a fortunate
circumstance for us.

HOODED MERGANSER
Lophodytes cucullatus

The narrow-billed hooded merganser is often referred to as a "fishduck," as small fish and crustaceans provide its main diet. Look for it along the streams and lakeshores which provide the necessary large, hollow trees for nesting.

Being cavity nesters, any rotten tree, stump or unoccupied pileated woodpecker hole suits them perfectly. The nest itself consists of material such as wood chips and sawdust mixed with down from the female's breast. For 31 days the female will incubate some six to 12 pure white eggs. Upon hatching, the young literally fall from the nest to the forest floor; these light little balls of fluff seldom have a hard landing.

OSPREY *Pandion haliaetus*

As fish is the staple of their diet, ospreys live close to lakes and rivers where this type of food is in abundance. They will dive into the water from fifteen metres or more to capture a meal, which could be equal to their own weight (1.75 kg - 2.25 kg).

Once again airborne, the osprey adjusts the position of the fish so that it is head first and offers less wind resistance. The osprey then proceeds to a favourite perch to eat its catch. During nesting season, the male eats only the head before presenting the rest of the fish to its mate and chicks. When very young the offspring are fed delicate morsels torn from the fish by the female.

Although fish is almost exclusively the osprey's preference, it will occasionally catch smaller rodents and birds.

These birds of prey can reach a length of approximately 0.6 m and have a wingspan of 1.8 m. Their large, flat nests are constructed mostly of interwoven twigs and branches placed high in the tops of dead snags or on power poles. Although they do not do so in the Rockies, in some areas they have been known to build on the ground. They live singly or in groups, depending on the location and the food supply. One pair in New England was recorded to have occupied the same nest for 44 years.

Ospreys may be seen in Canada from April to September, but are migratory and spend the winters in South and Central America.

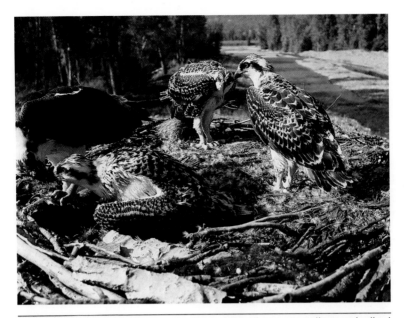

Dennis climbed to the nest where he set up a radio-controlled camera with a 35 mm wide angle lens. The adults were a little disturbed and flew off, but the young just calmly watched the whole procedure.

Attaching the camera (with string) to the side of the nest afforded an excellent opportunity for intimate behavioural shots. By setting the lens aperture at f11 and prefocusing 1/3 of the distance into the nest, adequate depth of field was assured. Varying light conditions were overcome by the use of the automatic shutter speed. With the motor drive on single frame mode, Dennis was able to choose only the best action shots from the cover of our blind many yards away. Binoculars helped in choosing the exact moment to activate the shutter and by keeping track of the number of exposures, it was possible to judge the end of the roll. Again Dennis climbed to the nest to retrieve the equipment without protest from the chicks.

BALD EAGLE *Haliaeetus leucocephalus*

Two of the largest broad-winged raptors in North America are the bald eagle and the golden eagle. Females may weigh as much as five kilograms whereas the smaller males reach approximately four. Wingspans can be up to 2.4 metres.

The bald eagle, America's symbol of freedom, mates for life and has been known to live 40 years or more. The remarkable eyes can zero in for a kill on a small animal from better than three kilometres. "Sea eagles" as they are sometimes called, prefer habitat close to lakes, rivers and oceans where fish abound. Although they prefer fish as a diet, they will eat any animal matter, including carrion.

It is not uncommon for these opportunistic birds to steal meals from ospreys. Once we watched an eagle take after an osprey which carried a fish in its talons, and pursue it high into the air where, after much harassment, the osprey dropped his catch. The eagle caught the fish when it had fallen less than five metres.

Most times, a large, rather flat nest of sticks lined with moss, feathers, grass and other soft material is constructed high in the fork of a large tree. Each year the pair increases the size until the nest may topple from its own weight. There is a record of one such structure weighing more than 2000 kg, while another measured seven metres deep and three metres across.

Usually two white eggs are laid with the female starting her 35 day incubation period as soon as the first is laid. This results in one chick's being larger than the other and, at times, the first born will kill or starve its sibling by fighting or demanding all the food for itself.

The young remain in the nest for ten or eleven weeks until strong enough for flight. Once away they are pretty much on their own but occasionally will return to the nesting area the next year only to be rejected by the adults. White feathers form on the head and tail when the bird is four to five years old.

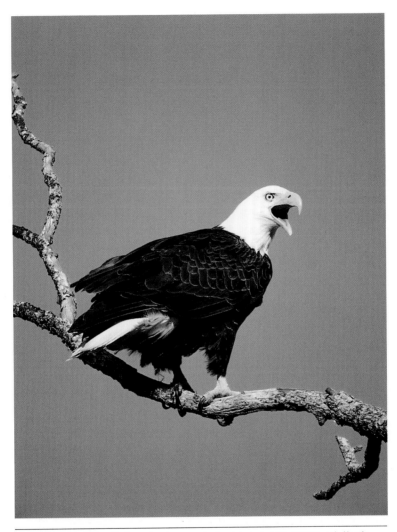

It is rather difficult to photograph bald eagles even at their nests, as they are shy birds. In this instance, magpies had built a nest into the base of the eagles' nest. The eagle was reluctant to leave the area for each time she did, the magpie would invade her nest to scavenge a meal from the chicks. The female stood guard on a branch close at hand while the male went hunting. By patiently waiting until the full sun peeked through the shadows of a nearby tree, we were able to capture this photograph with our tripod-mounted 800 mm lens. The exposure was evaluated using an incident meter reading.

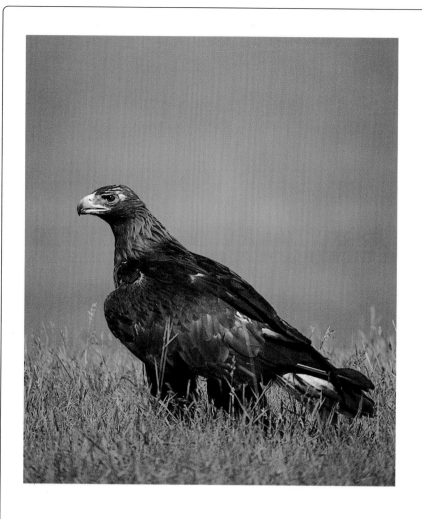

GOLDEN EAGLE *Aquila chrysaetos*

As it is about the same size as the bald eagle, the mature golden is often confused with an immature bald. Both birds feature mostly dark brown feathers but those of the golden eagle are golden at the back of the neck — hence the name. Immature golden eagles sport a broad white band on the tail, the tip of which is black. The feet of the golden eagle are feathered right to the toes, while the bald eagle's feet are bare.

Golden eagles are primarily associated with the high rugged country of the mountain areas. Their favoured nesting spots are located along inaccessible cliff ledges. Locating a nest is relatively simple with the aid of a good pair of binoculars, as over the years the young literally whitewash the surrounding area with excrement.

Seventy percent of the golden eagle's diet consists of rabbits and hares. Marmots, ground squirrels, grouse, and so on make up the remainder, but should the opportunity arise, the golden eagle will take young deer, sheep or goats. A remarkable flier, this large bird of prey can dive at over 241 km per hour, and it requires approximately 90 kg of food each year in order to survive.

Facing page: Always at the ready, our 200 - 500 mm zoom lens (mounted on tripod) captured this magnificent golden eagle as it devoured a ground squirrel. Exposure was set on automatic.

WHITE-TAILED PTARMIGAN
Lagopus leucurus

High alpine regions of the Rocky Mountains are home to the white-tailed ptarmigan. These 30 cm birds are well adapted to the cold climate as they readily change their coats to coincide with the seasons: black, browns and greys in the warm months change to pure white in winter. This cold-weather garb makes them very difficult to see, but their black eyes, bill and claws betray their presence in the snow. As the snows deepen and cover the alpine willow buds, the ptarmigan may be forced to relocate to lower elevations in quest of buds and twigs of alder and birch trees.

Late in June, the female scrapes a slight depression in the ground, lines it with fine grasses and deposits approximately nine pinky-buff spotted eggs. Her camouflaged coat of dappled greys, blacks and browns enables her to sit unnoticed while incubating her brood. During her daily feeding and leg stretching sessions over the next three weeks, the eggs will be well hidden, due to their spotted colourations. Within hours after hatching, the precocious chicks are eating seeds and insects.

Even though the ptarmigan does not encounter many people, it is quite easy to photograph providing you use patience and approach slowly.

Facing page: Both photographs were taken in direct sunlight using the incident reading method with a hand-held meter. This reads the amount of light falling on the subject for the correct exposure. In instances where the bird or animal is moving from place to place, the backgrounds may vary from light to dark. By taking a reading of the light falling on the subject, your exposures will be correct as long as your image is receiving full light.

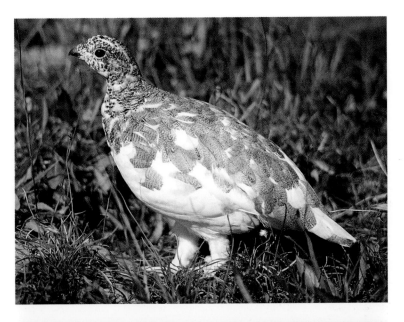

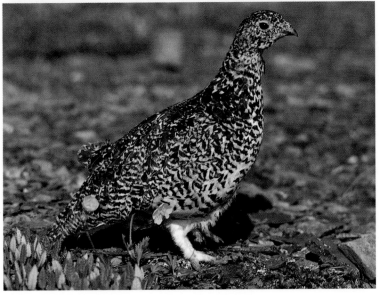

RUFFED GROUSE *Bonasa umbellus*

The ruffed grouse's name is derived from the practice of both sexes of puffing up the neck feathers when aroused or excited. These solitary, non-migrating, chicken-like birds may weigh up to .7 kilograms and reach a length of 45 cm. Short, rounded wings carry them speedily on brief, whirring flights. Open woods and aspen parkland assure a good supply of insects, berries, seeds and blossoms. During winter, the ruffed grouse relies mainly on aspen buds to relieve its hunger.

A small fringe of scales grows along the sides of each toe in winter, acting as webbing to improve the bird's ability to walk on snow. In extremely cold weather the grouse will dive headlong into the deep snow covering the forest floor, using the snow as insulation against wind and bitter temperatures.

In early spring the male stakes claim to a favoured log or rock from which he announces territorial ownership. By beating his cupped wings against his sides a progressively faster booming sound is produced. This display not only wards off males but also attracts females.

Facing page: After following the sound of drumming and spotting this male on his chosen log, Dennis crawled through dense undergrowth to reach a deadfall approximately 3.5 m from the bird. Using the deadfall as an emergency tripod, as the light was extremely low, he was able to get four pictures, using a 200 mm lens at f 2.8 with 1/4 second exposure, before the bird retreated. Although the grouse did not "drum," as the wing action is called, Dennis was happy with the results.

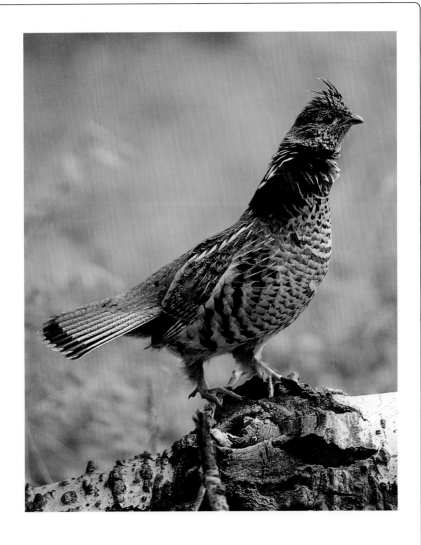

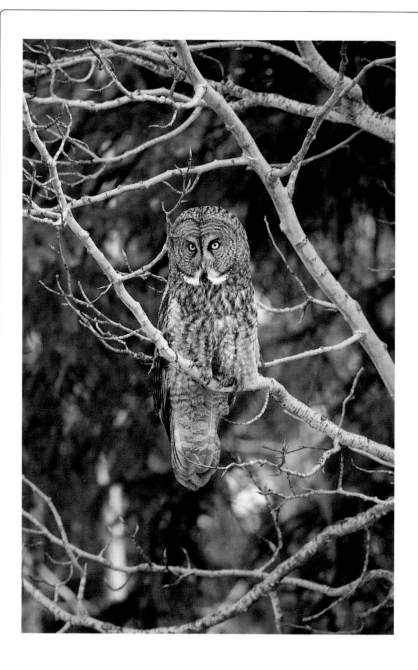

GREAT GRAY OWL *Strix nebulosa*

Sighting a great gray owl is an unforgettable experience, and a rare one. This, the largest owl in North America, has a wingspan of 1.5 m, a 30 cm tail and a body length (including tail) of 84 cm. Although it weighs no more than one kilogram, it can be as tall as a normal two year old child.

The owl's fascinating yellow eyes are fixed in the sockets, allowing only 110° vision (humans have 180°), but the bird pivots its entire head rather than just its eyes when focusing. Its ears are designed so that, even in total darkness, the triangulation system of pinpointing sounds results in successful hunting. This is aided by facial discs covered with specialized feathers which enable the owl to hunt by sound waves. Owl wing feathers have a unique hair-like extension to the leading edge which reduces air resistance noise, resulting in silent flight. Only the digestible parts of prey are digested: bones, fur and feathers form a pellet which is later regurgitated.

The great gray owl uses abandoned hawk, crow or raven nests. The female rarely leaves the nest during the first 10 weeks, when she is busy incubating and shielding the chicks from weather and predators. It is the male who supplies the food. Only while protecting its young has this awe-inspiring owl been known to attack humans; otherwise it is placid and seems uninterested in human presence.

Facing page: The owl's favoured prey, mice, voles and ground squirrels, is often found throughout the natural-looking meadows created by our road crews along the rights of way. We photographed in such a situation along the David Thompson Highway, which leaves Banff National Park at Saskatchewan Crossing. The 800 mm lens is too heavy and awkward to hand hold, and a tripod and a cable release are a must. In this case, we read our incident light meter for the correct exposure as the darker background would have thrown off the automatic reading. Make sure your meter is picking up the same light as is falling upon the subject.

BELTED KINGFISHER *Ceryle alcyon*

Wherever there are lakes and streams in northern North America, the kingfisher can usually be found. It is a hardy bird that finds no need to migrate so long as there is open water and a good supply of small fish. This solitary bird fishes either by plunging from a branch or by hovering directly above the water and diving on its prey.

The large head, sporting a prominent crest and oversized bill, makes the body appear top-heavy. In comparison to other fishing birds, the feet are small and weak. The kingfishers' cry is a continuous loud raspy rattle which is often used in flight.

To establish a nesting burrow, both birds dig for up to three weeks directly into a bank: sometimes 4.5 metres or more. The burrows, preferably near water, may be used again the following year. The female, with occasional relief by the male, will incubate perhaps eight eggs for 24 days. At times, when the female is incubating, the male will build himself a burrow close to the original nest for his own comfort.

Both parents feed the young chicks inside the nest for three weeks or longer before the young are strong enough to be on their own.

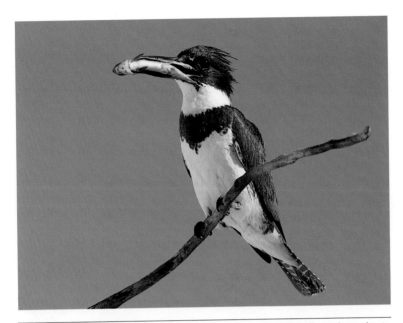

Experience has taught us that kingfishers habitually return to the same perch after a successful catch. We threw our "Duckman" blind over a branch, set up the tripod complete with camera and 200 - 500 mm zoom lens and the cable release (to avoid any camera shake), and captured many fine images over the next four hours.

The camera's automatic exposure system was used as the sky was a true blue and the bird was partially side-lit, which tended to even out the whites and the blacks and made compensation unnecessary.

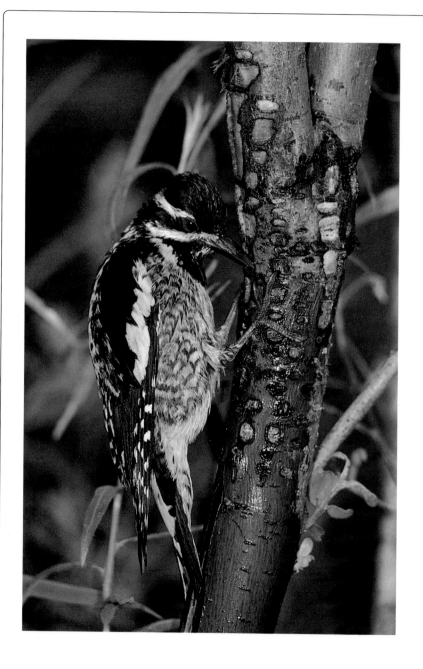

YELLOW-BELLIED SAPSUCKER
Sphyrapicus varius

This fascinating medium-sized (20 to 22 cm) woodpecker is found in stands of birch, aspen or alder trees. The yellow-bellied sapsucker seems to prefer aspen groves, and particularly those trees which have been attacked by a fungus growth which decays the core. Such trees make ideal nesting sites as the shell is hard for protection while the inside makes a lovely soft, unlined nest for four to six chicks. The same tree may be used for several years, but the same nest cavity will rarely be used again. Sapsucker nests are easily located, as the adults are very vocal when alarmed and stay near the nest.

Adults are identified by the red forehead patch and a long white area on the wings. The male has an additional patch of red on the throat, where the female's throat is only partly red. The chicks are brown, but still carry the white patch on the wing.

By feeding on insects in the bark, these birds rid the tree of many types of boring insects which destroy healthy growth. They also feed by drilling small, orderly holes around a tree to extract the sap, a practice which gives them their name. Insects caught in this sticky substance provide them with the protein they need, and hummingbirds regularly benefit from the unique feeding stations which sapsuckers create.

Facing page: Equipment used for this photo included flash meter, tripod, camera compete with 200 - 500 mm zoom lens, remote control cord, and two dedicated flash heads mounted on light stands and placed at an angle close to the feeding station, to simulate sunshine. With this kind of set-up, one light stand should be slightly higher than the other to achieve a more natural appearance, and the camera should be on the automatic setting.

NORTHERN FLICKER *Colaptes auratus*

The red-shafted phase of the northern flicker, found in the Rockies and westward, is very similar to the yellow-shafted phase which inhabits territory east of the Rockies. At the "border crossing," these two phases sometimes breed with one another, resulting in mixed colourations and markings.

With their strong bills, flickers hollow out cavities in trees, stumps or buildings at almost any height. The resulting wood chips act as the only nesting material. This beautifully marked woodpecker is uncommonly mild-mannered, and would rather quit than fight. Consequently, many a good flicker hole has been taken over by a starling.

The male of the red-shafted phase sports a definite red malar strip, or moustache, low on its cheek. Both males and females of this phase are identified by the predominant salmon-red colourations of the tail and undersurfaces of the wings. Their long, barbed and sharply pointed tongues are covered with a sticky saliva to capture many types of insects. Ants are a

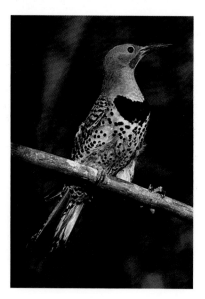

favourite food. While feeding its young, the flicker does not carry the food in its bill but deep within its throat to be regurgitated at the nest. Both sexes construct the nest, incubate and feed the young.

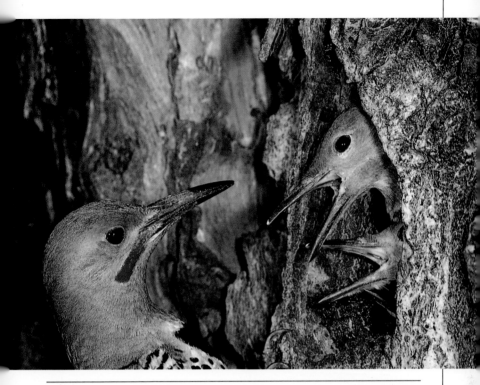

Above: Most flicker nests seem to be on the shady sides of trees, making it necessary to use flashes or reflectors. This photograph was captured using two flash heads (secured to light stands) placed close to and on either side of the nest at an angle, to create the illusion of sunlight. Our tripod-mounted 300 mm lens was placed close to the nest, prefocused on the entrance hole. We positioned ourselves at a distance with a remote control cord. Patience was required but no blind was necessary.

Facing page: The male repeatedly used the same branch as a perch whenever leaving the young at the nest. As the subject was in deep shade, it was imperative to use flash to pick up a light in the eye and also to bring out the pattern and bold colouration of the feathers.

GRAY JAY *Perisoreus canadensis*

Throughout the coniferous forests and wilderness areas of the Rocky Mountain parks, this plump-looking "camp robber" may be following you along the trails. Its flight is silent so you may be unaware of its presence until you stop for a snack. Then the bird will appear, hoping for a treat. It is wise to keep your food protected, however, as human snacks are not suited to jays any better than they are to other wild animals.

Do not underestimate the ingenuity of this clever, omnivorous thief: one stole a rasher of bacon from our hot frying pan one day. Insects, berries, other bird's eggs and chicks, carrion, and seeds form its more natural menu. An expandable throat pouch enables the jay to carry off an extraordinary amount of food at one time.

February is the start of the nesting season. No matter how cold or how deep the snow, the female will keep the eggs warm for approximately 18 days. The bulky nests are heavily lined with insulating material such as fur, hair and grass. The adult birds have a downy coat of feathers to withstand frigid temperatures. The gray jay does not migrate, but remains active all winter in the parks.

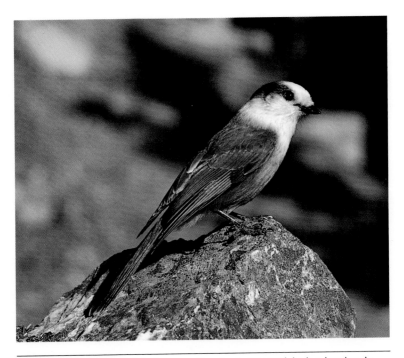

We photographed this jay on the trail around Lake Louise in Banff National Park, using available light plus a hand-held 200 mm lens. An incident meter reading was used because of the dark shadows on the trail which could have thrown off the camera's automatic calculations.

STELLER'S JAY *Cyanocitta stelleri*

The brash and beautiful Steller's jay is British Columbia's provincial bird. This crested jay is found in the Rockies and westward to the Pacific Ocean, its preferred habitat being pine and other evergreen trees, and oaks. The Steller's jay's reputation for boldness is well earned wherever an association with people has been established, but in the open woodlands, it is very shy indeed.

The nests of Steller's jays give the appearance that everything available, including paper, has been thrown together and cemented with mud. It is as though both sexes wanted to get this boring job over with and go on to other things. After helping build the nest, the male usually leaves his mate to look after the eggs for the next seventeen days or so.

The jay's voice is not what one would expect from a beautiful bird, but is rather a continuous *squack, squack, squack.* It is also an excellent mimic of the golden eagle and the red-tailed hawk.

Living outside the parks, we have set up a feeder in severe winters. One such winter, the feed purchased contained some corn. The resident Steller's Jay loved it, but we objected to its taking only the corn and scattering the rest of the seed. By installing a guard, we arranged it so that the feed could be reached only by pecking. Now we had one very upset bird on our hands. It berated us from the trees, the porch and the window sill. When we were outside, it would scold and plead with us continuously. Eventually it did calm down but never totally forgave us for spoiling its fun.

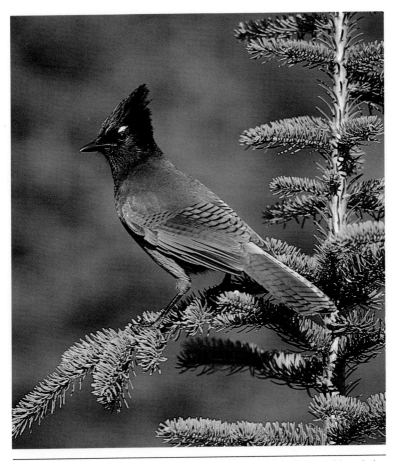

This particular jay, which we saw at Emerald Lake parking lot in Yoho National Park, was very inquisitive and greeted all newcomers with great enthusiasm. After watching it for some time, we saw that the bird always returned to the same tree. We moved closer to that tree and waited with our backs to the sun to ensure that the jay would be in full sunlight, to emphasize the beautiful blue colouration of his feathers and enable us to capture a light in its eye. The correct exposure in natural light conditions was arrived at with the use of a hand meter on incident reading. We used a hand-held 200 mm lens.

CLARK'S NUTCRACKER
Nucifraga columbiana

Captain William Clark, of the Lewis and Clark Expedition of 1803-06, is credited with the discovery of this relative of the crow family.

The nutcracker prefers high mountain country where ponderosa pines, juniper and larch are in abundance. Evergreen (coniferous) trees provide seeds as a chief food source. As the name implies, the nutcracker extracts the seeds from the cones by cracking them or by hammering with its sharp bill. The nutcracker will store seeds for spring in old trees, fallen logs or on the ground. It appears to have an unerring memory — months later, the cache will be retrieved, even after its been covered with heavy snow.

Both sexes build the nest of dry twigs, bark strips, grasses and pine needles. Only one brood is produced each year; two to four chicks will hatch in approximately 17 days. Being an early nester, usually in February, the nutcracker's young are on their own much earlier in the year than most.

The short, swooping flight pattern of the nutcracker is likened to that of the woodpecker, but the conspicuous black and white wings plus a short tail will confirm the difference.

Parking lots and picnic sites at higher elevations are favoured areas throughout the Rocky Mountain parks.

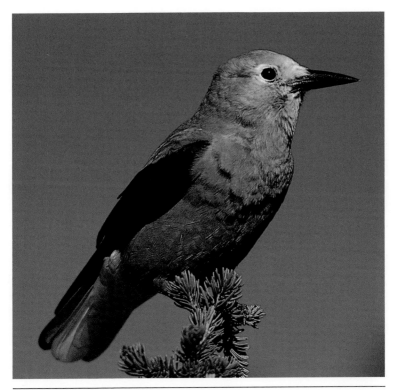

These birds are quite bold and will often land close enough for a photograph with a fully automatic camera. At Peyto Lake parking lot lookout, using natural light, we used a hand-held 200 mm lens.

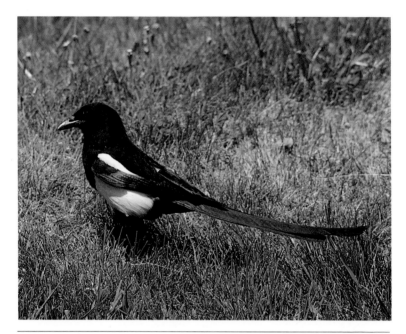

Using our 200 - 500 mm zoom lens, mounted on the window pod at the camper window, we had time for only one shot on the camera's automatic metering system before the magpie left the scene.

BLACK-BILLED MAGPIE *Pica pica*

With a green metallic sheen to its black coat, white wing patches that flash in flight and an iridescent greenish black tail that is longer than the 25 cm body, the magpie is one of the most attractive members of the crow family.

This highly intelligent scavenger is ever alert for a free meal and is a notorious robber of birds'nests. The magpie is often seen at the kills of other predators, waiting for the opportunity to steal the scraps. It will also ride the backs of elk or sheep for a feed of ticks or insects the animals kick up. At the town parking lot in Banff, enterprising magpies will scrutinize the fronts of vehicle for insects. When the magpie is full, its large bill is used to transport extra rations to hiding places. At times, magpies will construct their nests close to nests of eagles or ospreys, in order to pilfer from the chicks when the adults are away.

The magpie nests in small scattered colonies. With mud or cow dung as a base, the nest is a bulky, enclosed mass of intertwining sticks and twigs, usually in thorny, inaccessible bushes such as hawthorn. An inconspicuous entrance hole is constructed on one side, and an exit hole on the other, with a roof covering the entire nest. Both male and female magpie will spend as long as six weeks completing this structure. When finished, the female will lay one egg each day until she has several, incubating only when the last egg has been laid.

COMMON RAVEN *Corvus corax*

With a wingspan of 1.25 m, the raven is the largest member of the crow family and the largest in the order of passeriformes (perching birds) which represent three-fifths of all the world's living birds. They have three toes forward and one back, all on the same level, permitting an exceptionally firm grip. In flight not only do they flap their wings, but they soar with the ease of an eagle. It is a remarkable sight to watch a pair (which mate for life) soaring, dipping, diving and rolling with total abandon for hours at a time.

Often thought to be the most intelligent of birds, the raven has a variety of habitats ranging from the mountains to the oceans; even the deserts are home at times. Together, a pair will often build a nest on top of last year's, adding more branches, bones, twigs, and so on, while lining it with hair, grass, fur or other soft materials. It is almost always the female's job to incubate the four to seven eggs for a period of about twenty-one days. The large nests are usually in the most inaccessible of places such as a very high tree or a steep cliff. Such a nest is located in Banff National Park just north of Rampart Creek Campground. From the turnout, in early June, your powerful binoculars or spotting scope can give you an intimate view of feeding activities high upon the cliff face.

A shiny, metallic black coat and a very large gently curved bill identifies this member of nature's sanitation crew. Methodically it searches for and cleans up road kills. Basically a scavenger but also a predator, it will dine on anything from berries to ripe carrion.

Nature never ceases to amaze us. While in a wilderness area one day, we noticed this juvenile raven feeding. He seemed unafraid so Dennis slowly crawled forward and placed his hand on the ground within centimetres of the claws. The young raven hopped aboard and allowed Dennis the thrill of holding a wild bird. After several photographs it launched itself, circled overhead a few times before disappearing over the forest.

This photo was taken with a normal lens (50 mm) in natural sunlight. Exposure was on automatic as the black bird did not fill the frame and everything else in the picture was lit normally. The story to be told was not in the bird alone but rather its friendliness towards a human. Had the bird been the only subject in the frame, we would have gone manual using an incident meter reading and opening the aperture at least one full stop in order to gain the feather detail.

WHITE-BREASTED NUTHATCH
Sitta carolinensis

A resident bird, the white-breasted nuthatch seldom migrates, but prefers to spend the winters in similar habitats to those of chickadees and kinglets.

This small (15 cm) dapper bird is a cavity nester, favouring natural hollows. Nuthatches frequently will take up residence in an old woodpecker hole, and if really desperate, they have been known to create their own. The female collects the nesting material and incubates the eggs. The male feeds the young and also, at times, his mate. Some naturalists believe that nut-hatches mate for life.

A bill resembling a woodpecker's and strong feet are most useful as these birds scurry down trees, searching for insects hidden under bark scales. While other creeper-style birds, such as woodpeckers, feed from the bottom of the tree upward, the white-breasted nuthatch feeds upside down, approaching in-sects from the tops of the bark scales. This feeding system assures the bird of a generous food supply, as it catches insects other birds have missed.

While hiking the forest trails, you may be fortunate enough to observe this unique and fascinating bird. Listen for a nasal *yank, yank* or *zeep, zeep* call: nuthatches call often.

Facing page: As this particular nuthatch preferred one particular route to its nest, we directed the lights at that area. The hand-held camera was equipped with a 200 mm lens and was connected to the lights by a long extension cord. When using dedicated flash units with your camera set on auto-matic, the exposure is adjusted automatically by the camera.

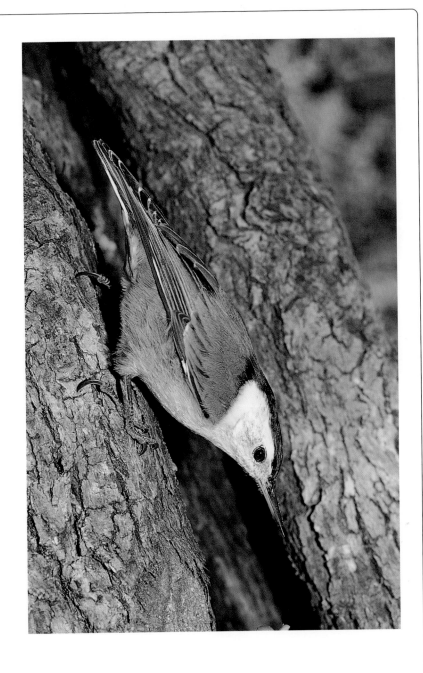

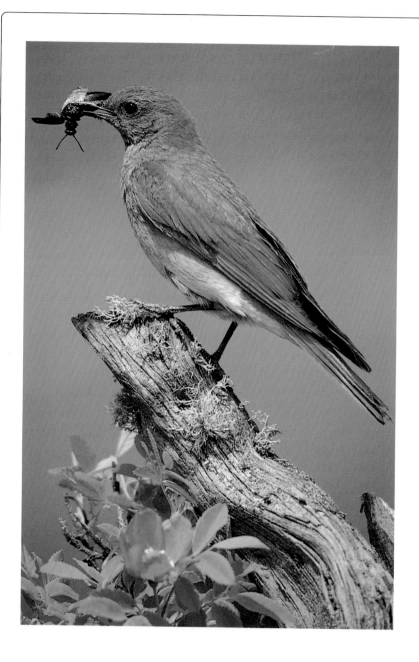

MOUNTAIN BLUEBIRD *Sialia currucoides*

Throughout the entire world the only natural home of bluebirds is in North America. Not too long ago, the future of these beautiful songbirds was in doubt, but thanks to conservationists' nesting box programs, the bluebird is now doing quite well. The bluebird is a migrant: flocks prepare to leave for the southern United States or Mexico in mid-July, and return at the end of March regardless of weather conditions.

Selected aspen groves, close to water, are common nest sites where nesting boxes are not available. Being cavity nesters, but not having the bills to tackle such a job, bluebirds will occupy natural cavities or vacated homes of the smaller woodpeckers. Four to six pale blue eggs are incubated for two weeks, after which both sexes will feed their offspring. Sometimes, the female will leave the male to feed the first batch while she takes off to start another.

Humans value this rather small (18 cm) bird very highly, not only because of its beauty but also because of the many insects it devours, the blue damselfly being high on the list. Bluebirds seem to co-ordinate the hatching of their chicks with the hatching of these insects.

Facing page: To improve the photograph, we glued some lichen to a prop close to the nest. Out of focus green leaves in the background contributed to the pleasing colour combinations while permitting the bluebird to stand out strongly. A sunny day, a tripod, a cable release, a 200 mm lens and the camera set on automatic produced this shot.

CEDAR WAXWING
Bombycilla cedrorum

This magnificent songbird is particularly attractive to the photographer. Body feathers are sleek with rich, soft harmonious colours. Tail feathers are tipped in a striking yellow while bright red spots are displayed on the tips of the wings, a glorious crown features the same hues as the body and a black mask completes the picture.

It is from the spots on their wings that this starling-sized bird is named; most adults display waxy-looking red tips on their secondary feathers, which show up beautifully in flight.

Waxwings are found throughout Canada's open woodlands, along the streams and beside the lakes where an abundance of berries, seeds and insects is likely to be found. Sociable, friendly birds, they form flocks of three or four dozen or more from late summer until early spring. They do not migrate but move with the food supply, which consists of dried berries and orchard fruit after harvest.

These fascinating birds show a tenderness towards each other. Frequently a pair will alight on a branch, the male passing a berry or a flower petal by his bill to his mate. She accepts the gift and passes it back to him. This display may be repeated several times. Several waxwings will occasionally line up, passing their offering amongst themselves until one swallows it.

Both sexes work together at building the nest (which often contains string or yarn). The female does the incubating and the male helps with the feeding. Frequently the same pair will raise a second family.

Facing page: By using a five-foot section of our portable 20-foot tower, we were able to set up our equipment on a level with the waxwings' nest. Several small branches and leaves obstructed our view so, with the use of some string, we tied them out of the camera's view, to be released after the photo session.

As we do with most birds' nests, we employed a 200 mm lens on a tripod. Our two dedicated flash heads (mounted on light stands) produced the power and our remote control cord permitted us to photograph on automatic setting from a distance.

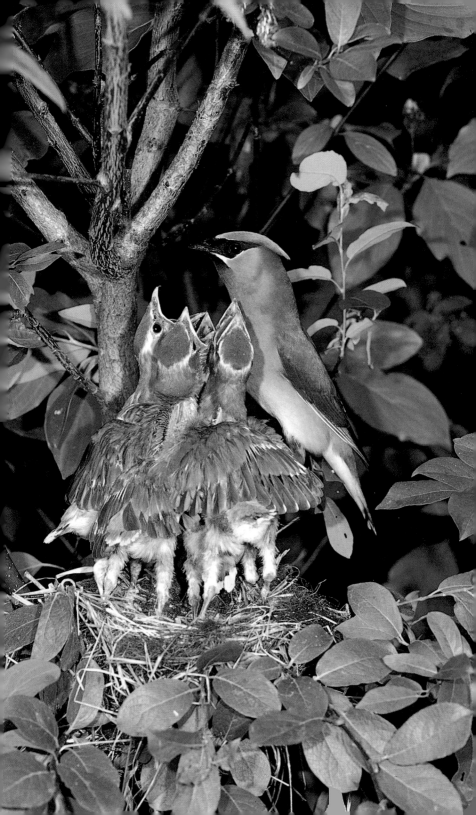

FROGS
FLOWERS
& INSECTS

FROGS

There are approximately 2,500 types of frogs and toads world-wide but less than 30 species are found in North America. Of the fewer than twenty species of frogs found on this continent, two have been introduced from other countries.

A frog's smooth skin is kept moist by a slime-producing gland on the skin itself. Its long hind legs, equipped with webbed feet, are used not only for travel but as a means of escape from predators. Frogs are hunters of worms, insects and small animals, and they are found in most bodies of water with aquatic vegetation.

The frog's tongue is attached to the front of its mouth, allowing it extensive reach. A fast flick of this sticky, muscular tongue

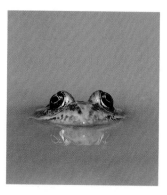

and the frog has its prey, which it quickly and efficiently brings into its mouth. A frog cannot chew but must swallow its food whole; this process is assisted by mucous secreted from the remarkable tongue.

The frog's distinctive call serves to entice females to breeding areas where mating is done in the water. As the male grasps the female from the top, wrapping his front legs firmly around her body, he releases sperm to fertilize as many as 20,000 eggs. These eggs are laid in a jelly-like mass generally anchored to aquatic plants. The adults then abandon the eggs.

If the water is warm, the eggs will hatch into black tadpoles within three days but, if cold, it could take up to two weeks. Very few tadpoles survive the many predators. Gills show outside the body early in development but soon disappear. A horny black beak is produced, serving as a mouth through which vegetation, small animals or even other tadpoles are devoured.

Hind legs appear first, then the front. As the lungs develop the tail gets progressively shorter. Bony, toothless jaws form, replacing the beak with a mouth. Once the frog has fully formed it is ready to move onto land. The entire process could take up to almost four months.

Frogs are rather difficult to photograph as they are shy creatures having many hiding places in the weeds of shallow ponds and backwaters. They can feel the vibration of your footsteps and will disappear in a flash but, if you keep still and

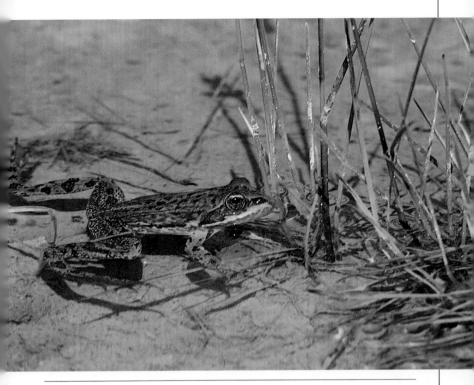

Above: The leopard frog was sunbathing in a shallow stream where there were not many places to hide. Moving very slowly, we were able to get close enough to use a 50 mm lens equipped with a polarizer to eliminate the shine from the water's surface. The automatic setting on our camera was used as the frog and the surroundings were compatible with the gray card.

Facing page: We discovered this specimen in a muddy roadside puddle where he seemed quite content to pose for us. By using a low angle to set up the tripod complete with camera, cable release and a 200 mm lens (fitted with extension rings), it was possible to capture a compelling composition. There was no need to compensate, as the brightness of the water coincided with the automatic exposure setting.

silent, they may return. Keep your camera ready, and be prepared to wait. If the water is dark, you must compensate for that by allowing more light to reach your film. Take an incident meter reading and open up the aperture by at least one stop (depending on the darkness of the water). In other words, if your meter reading is f 8 at 1/250 of a second, change your aperture to f 5.6 for a truer reproduction.

Springtime is the easiest time for photographing frogs as their mating calls will guide you to their sanctuaries. Finding one in a small, isolated pond will increase your chances of a good photograph.

BLUE CLEMATIS *Clematis columbiana*

While exploring open woodlands or talus slopes one might come upon this lovely climbing vine twining among branches and shrubs. As the 5 cm blooms, in varying shades of blue and purple, wither and die they are replaced by woolly clusters of seeds each possessing a long, curly tail fringed with small hairs. These seeds are very attractive. In the garden varieties, the seed pods are often used in floral arrangements.

The clematis is not very abundant but is a treasure to behold and often the highlight of a nature lover's day. Rain is sometimes an asset when photographing blue flowers as was the case in this instance. Just remember to keep the camera dry.

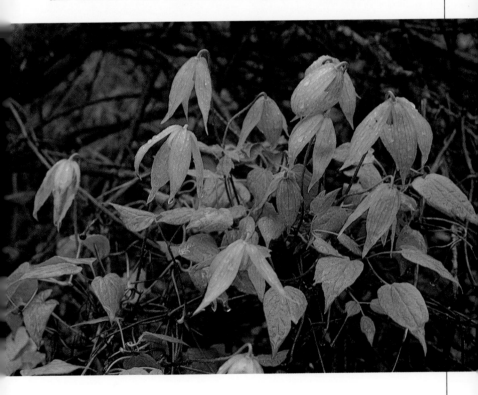

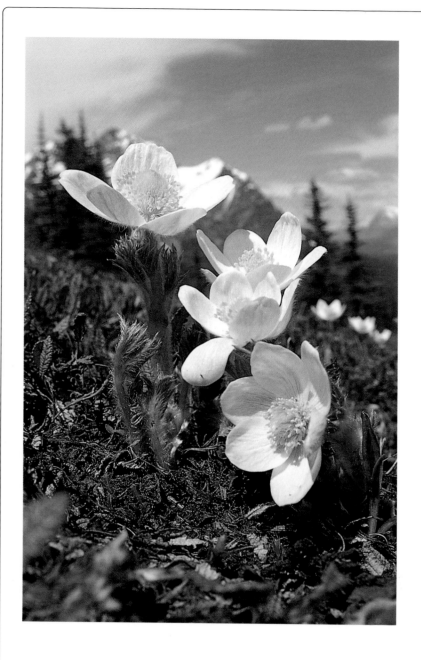

GLOBEFLOWER *Trollius laxus*

This denizen of high mountain meadows often pushes itself through the last vestige of snow for it is one of the first alpine plants to bloom. It is well equipped for the early season with a thick layer of fine insulating "fur" capable of withstanding frosty nights. The flower itself is globe-shaped having outer sepals enclosing a powder puff of stamens and pistils.

A feeling of "being there" was achieved in this photograph by placing the camera on the ground for a low angle that includes the habitat. The camera's aperture was set at f 22 while using a 35 mm lens plus a #1 extension tube.

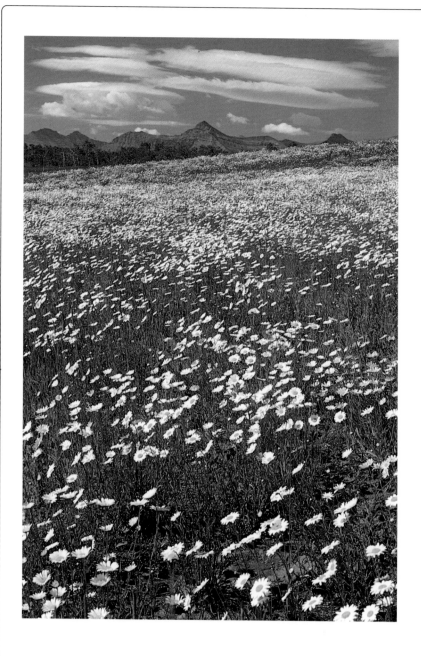

OX-EYE DAISY
Chrysanthemum leucanthemum

So named because the flower resembles the eye of an ox with its great fringe. In certain areas, June heralds this extremely prolific plant which covers hills and pastures with millions upon millions of lovely white blossoms for several weeks. Such profusion attracts numerous winged insects to feast upon the nectar and unintentionally to pollinate the flowers — thereby ensuring another fabulous crop next season.

Standing knee deep in daisies on a windless day, we chose a 28 mm lens plus polarizer to capture the multitudes of happy faces reaching for the sun.

BERGAMOT *Monadra fistulosa*

Bergamot is a member of the mint family sometimes found in
large patches in open fields. At other times, a solitary plant will
rise from the grasses.

Our intention was to capture
the mood of a large bed of flowers
but, due to the high wind, it was
impossible to gain enough depth
of field using the normal or wide
angle lens. Instead, we chose to
isolate one flower in sharp focus
and fill the background with pleas-
ing colour from several out of fo-
cus specimens. To accomplish this
we used extension rings, the
200 mm lens set at f 4 and a shut-
ter speed of 1/1000 second to
eliminate the wind problem.

WILD CROCUS *Anemone patens*

Being one of the earliest blossoms of spring, the crocus sports a coat of fine, thick "fur" to guard against the cold. Eight centimetres blue-lavender, purple or sometimes white flowers may be seen in the lower valleys as early as April as they emerge from under the rapidly receding snow.

As with tiny mammals, a much more artistic and intimate picture of small flowers will result by putting yourself on their level. Try to "shoot" the plant to show its entire makeup.

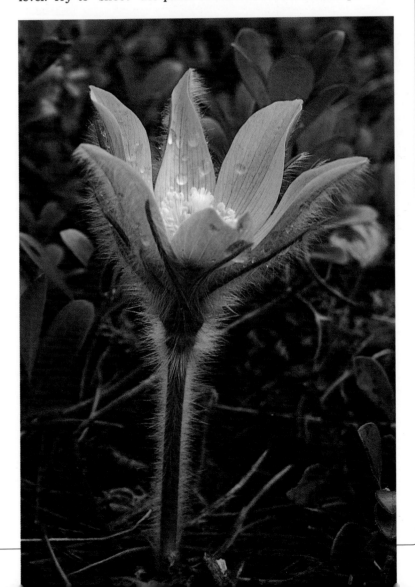

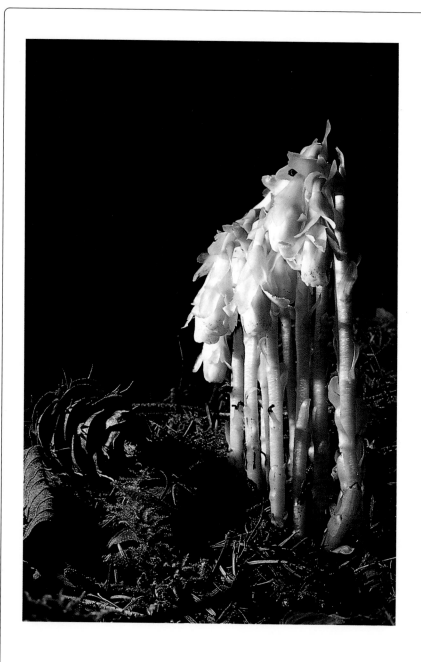

INDIAN PIPE *Monotropa uniflora*

The Latin name translates to "single flowered." It is often referred to as the ghost-plant due to its lack of colouration or Indian pipe as the resemblance to a smoking pipe is remarkable. A rather short (approximately 18 cm), fleshy and completely waxy-white plant found sparingly in tight groups usually within the deeply shaded areas of coniferous forests. The total absence of chlorophyll identifies this plant as a saprophyte living entirely off decaying vegetation.

Pieces of rotten wood supported the camera close to the ground. The fir cone at the base added interest and scale. A dedicated flash unit on an extension cord was held to the left for strong modelling.

MOUNTAIN LADY'S SLIPPER
Cypripedium montanum

Also known as moccasin flower or white lady's slipper. It is a rather rare, delicate, fragrant plant which is more often than not killed by attempting transplant to home gardens. Picking of blooms and leaves results in the destruction of the root system. By doing so, nourishment is cut off and the plant cannot survive. Such beauty should be admired, photographed and allowed to grow for others to enjoy.

Soft light from an overcast sky reveals the velvety texture of this beauty. Exposure was evaluated with an incident light meter.

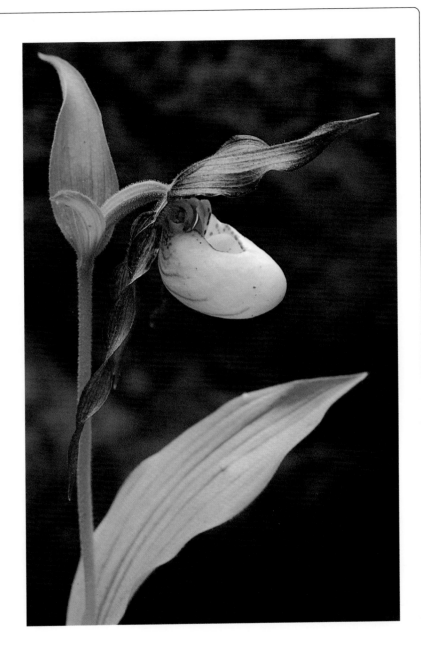

Frogs, Flowers & Insects 171

CLOUDED YELLOW *Colias crocea*

Our many-pocketed vests are ideal for carrying such equipment as camera, extension tubes, various small lenses, film and flash unit just in case we come across any interesting insects on our evening prowls.

Luck was with us when we located this beautiful butterfly in a large patch of fireweed. What a magnificent colour combination! To reach between the flower stocks we chose the 135 mm lens with extension rings. Flash was used to accentuate the insect and darken the background (available light being lower than the flash power). This photograph was the result of holding the camera in one hand and the flash in the other. The flash was held to avoid shadows on the subject from other flowers.

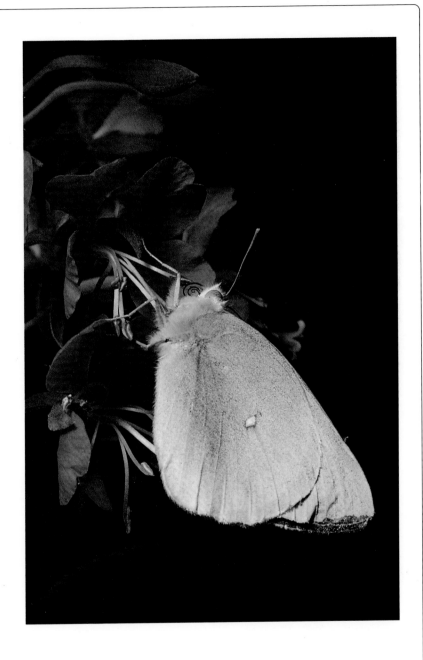

GRASSHOPPER Acrididae Family

While searching for deer one chilly autumn morning, our attention was directed to the grasshopper warming up on an interesting plant. By hand-holding the 200 mm lens we composed to soften the background by using a large aperture opening of f 4, which gave a shallow depth of field. Exposure was automatic, as the colour tones were compatible to a gray card reading.

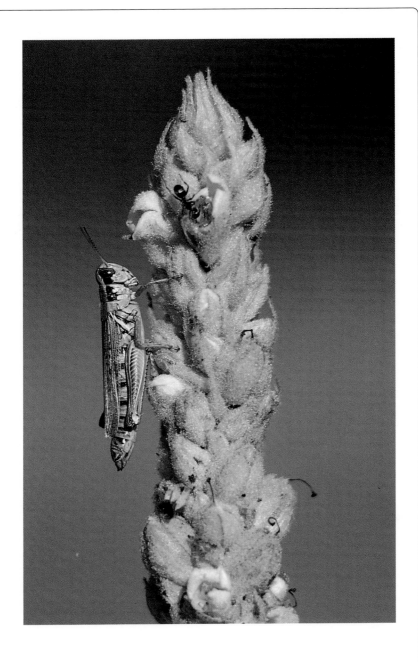

KATYDID Tettigoniidae Family

Many insects are stirred into action during warm summer evenings but few advertise their presence through sound. The male katydid attracts females in a unique way by vibrating the sound-producing structures located on his wings.

To add mystique to this night scene, a single flash head was used off to the side for strong modelling.

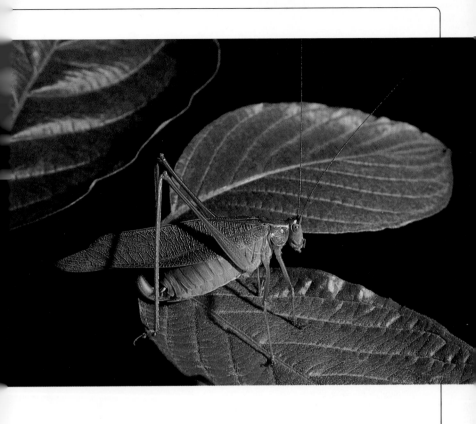

DAMSELFLY *Enallagma civile*

Returning to shore after a canoe photo session with loons, we noticed this lovely well-balanced composition. To our delight, not long after setting up the 200 - 500 mm zoom lens on tripod, two dainty damselflies alit. An incident light meter reading evaluated the light falling on the subject, eliminating any guess work as to what the shadows and water might do to the exposure.

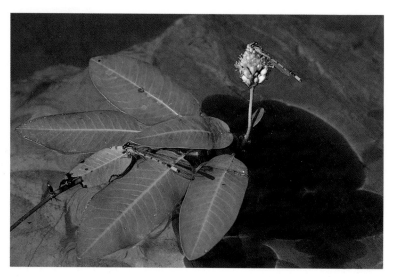

POLYPHEMUS MOTH
Antheraea polyphemus

Having a wing span of between 10 and 13 cm sets this insect apart as one of our largest and most attractive moths.

This beauty was photographed at rest during the cool of the evening using two flash heads to accomplish good exposure balance.

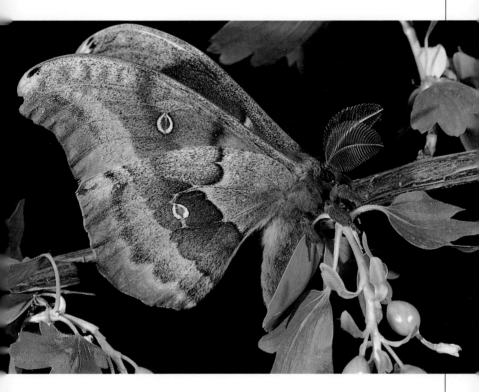

CUCKOO WASP Chrysididae Family

"What a lovely picture," we thought as we observed this colorful green wasp light upon a beautiful shining arnica bloom. We caught the wasp in a pill bottle and placed the container in the fridge for half an hour. We decided to use the hand-held flash unit (equipped with extension cord to the camera) in conjunction with a 50 mm lens (aperture at f 22 for a greater depth of field) and extension rings.

The dormant wasp was placed at a pleasing angle on the flower. With camera in one hand and the flash unit (angled at 45° to represent sunlight falling on the subject) in the other we were able to make two exposures before the wasp flew away.

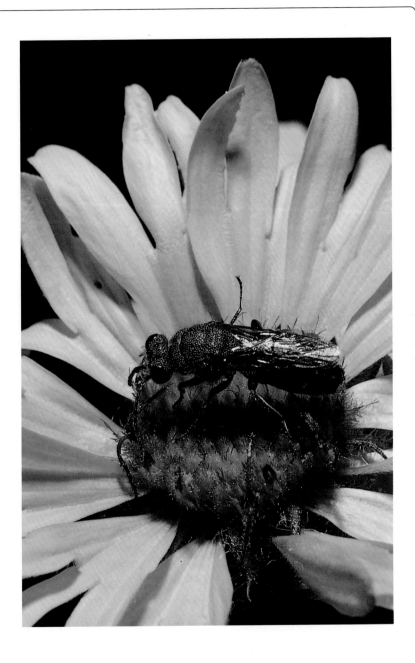

BUMBLE BEE Apidae Family

The bull thistle is an excellent subject by itself, but when an insect alights to feed from the colorful bloom it adds life and interest.

To prefocus on a bloom, thereby arriving at the most appropriate image size, we mounted a 90 mm macro lens on camera and secured an extension cord to the dedicated flash unit. While holding camera in one hand and flash (angled in front of and above the subject) in the other, dramatic top light was achieved. Ambient (available) light was not full bright and the aperture was set at f 22 with a shutter speed of 1/60 second; therefore, the exposure from our flash unit was brighter than the natural light, resulting in a dark background.

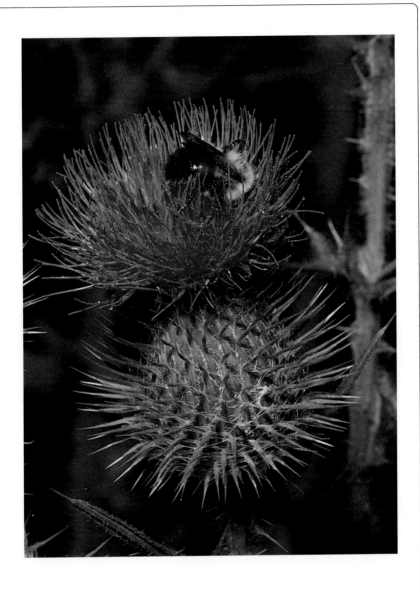

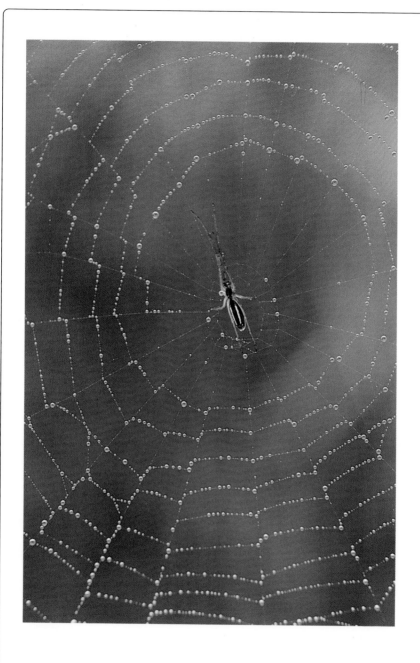

ORB SPIDER Araneidae Family

Don your rubber boots for a jaunt into a misty meadow on a cool day. Don't forget your camera and tripod for many a jewel-studded web may be found complete with a lovely fat spider. Locate one where the background is not distracting. Set the camera on a tripod, using your normal lens (50 mm) with the aperture at f 8 or thereabouts and the shutter speed on automatic. Focus critically on the web and the spider. Air circulation may disturb the fragile web, but be patient for the time may come when all is calm before the dewdrops evaporate.

WOLF SPIDER Lycosidae Family

This is probably the most common spider in the high mountains.

No web is built to trap food but rather this 24 mm arachnid stalks its prey by very keen vision and an excellent sense of touch. The female spins a sack for the eggs which is carried attached to her spinnerets. Upon hatching, the dozens and dozens of young spiders climb onto the female's back for security until able to fend for themselves.

By using the 90 mm macro lens and one dedicated flash unit held off camera with an extension cord, we were able to achieve several fine photos as she lay in the warm sunshine.

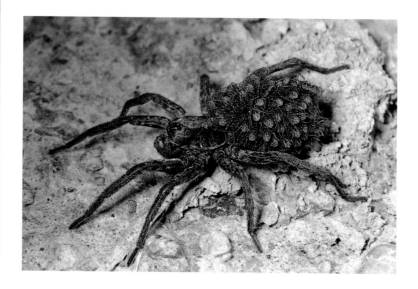

GOSSAMER THREADS Agelenidae Family

The low morning or evening light of autumn, when spiders are most active in making webs, affords great opportunities for interesting and exceptional photographs.

To compress distance and achieve a lovely tight composition, our tripod-mounted 200 mm lens set at f 32 on automatic exposure succeeded in giving a sharp image throughout the entire scene.

CONVERSION TABLE

LENGTH

1 cm	=	0.394	in	1 inch	=	2.540	cm
1 m	=	39.370	in	1 yard	=	0.914	m
1 m	=	1.064	yds	1 mile	=	1.609	km
1 km	=	0.621	miles				

WEIGHT

1 g	=	0.035	oz	1 oz	=	28.35	g
1 kg	=	2.296	lbs	1 lb	=	435.60	g

REFERENCES

Bogert, Charles M. *The Animal Kingdom*. 1954. Greystone Press.

Clark, Lewis J. *Wild Flowers of British Columbia* 1973. Gray's Publishing Ltd.

Harrison, Hal H. *A Field Guide to Western Birds' Nests*. 1979. Houghton Mifflin. Boston.

Levi, Levi and Zim. *Spiders and their Kin* 1968. Western Publishing Co. Inc.

Loates and Peterson. *Mammals in Profile*. 1975 and 1976. Cerebrus Press, Inc.

National Geographic Society. *The Secret World of Animals*. 1976.

National Geographic Society. *Wild Animals of North America*. 1986.

Peterson, Roger Tory. *A Field Guide to Western Birds*. 1961. Houghton Mifflin. Boston.

Savage and Savage. *Wild Mammals of Western Canada*. 1981. Western Producer Prairie Books. Saskatoon.

Savage, Candace. *The Wonder of Canadian Birds*. 1985. Western Producer Prairie Books. Saskatoon.

Stebbins, Robert C. *A Field Guide to Western Reptiles and Amphibians*. 1966. Houghton Mifflin. Boston.

Terres, John K. *Encyclopedia of North American Birds*. 1980. Alfred A. Knopf.

THE AUTHORS / PHOTOGRAPHERS

Dennis and Esther Schmidt left high pressured employment in the mid 1970s, but soon lost interest in just "being retired." In 1979 they decided to take up nature photography

to combine their great love of the outdoors with the challenge of the camera.

Their works have been published in Canada, U.S.A., Europe and Japan in books, magazines, calendars and encyclopedias, and on post cards and record jackets. Their first book, *Western Wildlife*, published by Oxford University Press (Canada), has proven a great success among nature lovers of many countries.

Dennis and Esther have shown, to themselves and others, that the so-called "autumn years" can be extremely rewarding and exciting.

The following titles are also published by Lone Pine Publishing:

The Compact Guide to Birds of the Rockies
Geoffrey L. Holroyd and Howard Coneybeare

This habitat guidebook to birds of the Rocky Mountains includes unusual and useful notes for more than one hundred birds, as well as typical locations. 120 full colour illustrations assist identification.

4 1/4 x 5 3/4	144 pages	
ISBN 0-919433-52-9	papercover	$9.95

The Compact Guide to Wildflowers of the Rockies
C. Dana Bush

This habitat guidebook describes one hundred species of wildflowers commonly found in the Rocky Mountains, classified according to elevation and topography to assist in their location. Watercolour illustrations by the author make this a beautiful little book.

4 1/4 x 5 3/4	144 pages	
ISBN 0-919433-57-X	papercover	$9.95

A Habitat Field Guide to Trees and Shrub of Alberta
Kathleen Wilkinson

This Lone Pine Field Guide to Alberta's trees and shrubs describes species found throughout the province and illustrates each in full colour. The book contains information on habitats as well as the anthropological and industrial uses of trees and shrubs.

5 1/2 x 8 1/2	192 pages	full colour photos throughout
ISBN 0-919433-39-1	papercover	$19.95

The Canadian Rockies Access Guide (revised & expanded)
John Dodd and Gail Helgason

Including 115 day hikes, along with information on backpacking, boating, camping, cycling, fishing, and more, *The Canadian Rockies Access Guide* covers Banff, Jasper, Kootenay, Yoho and Waterton National Parks, and Kananaskis Country.

5 1/2 x 8 1/2	360 pages	90 b/w photos, 54 trail maps
ISBN 0-919433-29-4	papercover	$12.95

Alberta Wildlife Viewing Guide

Take a walk on the wild side using this comprehensive guide to more than sixty of Alberta's finest wildlife viewing sites. Includes information on where to look for Alberta's special species, seasonal indicators, tips on wildlife photography, maps and photos.

5 1/2 x 8 1/2	96 pages	full colour photos throughout
ISBN 0-919433-78-2	papercover	$7.95

Look for these books at your local bookstore. If unavailable, order direct from Lone Pine Publishing, 206, 10426-81 Avenue, Edmonton, Alberta T6E 1X5 Phone: 403-433-9333 Fax: 403-433-9646